Don't Play Like a Girl

A Midcentury Woman Leaps into Life

Zelda Gamson

In memory of William A. Gamson

Dedicated to our children, Jennifer and Joshua Gamson

"It takes a heap of resolve to keep from going to sleep in the middle of the show. It's not that we want to sleep our life away. It's that it requires certain kinds of energy, certain capacities for taking the world into our consciousness, certain real powers of body and soul to be a match for reality."

—M. C. Richards, *Centering in Pottery, Poetry, and the Person*

Don't Play Like a Girl
A Midcentury Woman Leaps Into Life

©2023 Zelda Gamson

print ISBN: 979-8-35091-773-4
ebook ISBN: 979-8-35091-774-1

Contents

PREFACE:

A New View

I AM LOOKING FOR BIRDS OUT OF MY WINDOW. IT'S SPRING-time for the songbirds to announce the light. But for the first time in my life, in my late eighties, I live in an apartment building, and I can't see the birds.

I moved here of my own free will. It made all sorts of practical sense: my husband was sick and unable to help me keep up the house we'd built, lived in, and loved on Martha's Vineyard. We could afford an apartment here in Brookline where we would be close to one of our kids.

But what makes sense doesn't always feel right. And now that I've been here for a few years, and my husband has died, leaving me with time to reflect, I've started wondering what the concept of "free will" really means. My life has been a gift, full of joy, love, dancing, travel, protest, fulfilling work, children, and grandchildren. Many of the objects in my new home stand as testament to my adventures and to my dreams realized: a pair of red, spike-heeled sandals; a brown felt cowboy hat; works of art made by my daughter and friends; books I have written and edited; stacks of sheet music. But when I think back on the shape of my life—with its many forks and switchbacks, with all the paths I took and the ones I never followed—I see that even as I chose freely, I did not always feel free to make alternative choices. I've lived as a bold woman during a span of time in which bold women have come at least to be tolerated, but I still struggled,

as a wife and mother, to make space for myself—for my own work and my own peace, in particular. I struggled to "do it all" long before anyone started writing think pieces about how doing it all is impossible. And I wound up living a life that, in retrospect, looks nowhere close to as shapely as that of my husband. He was a renowned academic who wrote, taught, gained tenure, and then wrote and taught some more. His career was the center of his life.

My life cannot be so easily summarized. So, I decided to write this book.

When my son, Josh, a writer and professor, asked me what the book is *really* about, out of my mouth came, "It's a story about a talented girl who threw herself into life, wanted a lot, had to struggle to get it, and was often blocked, silenced, and/or outsmarted. I still have a lot of anger about that, and I'm far from feeling at peace."

What I might have said, had I been a little more prepared, is that my book is about many things, but running throughout it is one constant: for much of my life as a smart, spirited girl and woman (my nickname in college was "Zelda the Fire-Eater"), each time I found myself facing a wall, I believed it was about me. When at fifteen I was told to not play piano like a girl, I felt shame. When at nineteen I had to drive through the night to a seedy motel to get an abortion, I felt panic. And when after I was married I was asked why I should get a fellowship if I was only going to go and get pregnant, I felt outrage. No matter how many incidents like these occurred, each felt like the first, leaving me blindsided. Yet I never gave up: I improvised workarounds, I retreated, and I fought back. It took me decades to see clearly that my experiences were not unique but shared by women of all ages, places, classes, and races, many of whom have faced oppression from multiple directions.

I still feel far from peace. But what's important is that in these pages, I've looked at my life in a new way, allowing it to be full of contradictions: love and hate, joy and depression, shame and pride. I've written more freely than I was able to as an academic. I hope my life inspires other women, as well as men, who want to lead full lives and who find that they must break down barriers to get there.

Here goes.

1

Marshall Street

ON THE WALL BY THE KEYBOARD IN MY OFFICE HANGS A black-and-white picture of Marshall Street, in North Philadelphia, from 1940. I left Philadelphia in 1954 for college and could count on both hands the number of times I came back to visit my family. But recently I have dreamt about Marshall Street and wondered if I could find anything on the Internet about it. When I found the picture, to my surprise, I was overcome with joy. The street looked just as I remembered it as a small child.

If you didn't know Marshall Street, it would look like any other old-timey shopping street in a working-class neighborhood. A smaller version of New York City's Lower East Side, it consisted of two blocks of stores owned by immigrant Jews from Eastern Europe. Pushcarts that slept overnight at curbs came to life during the day with people selling vegetables, horseradish, roasted peanuts, women's purses, and children's clothing.

To me, though, Marshall Street felt like home. I can hear the peddlers calling out their merchandise. I can smell the pickles in the barrel at my great-aunt and great-uncle's grocery store down the street. Looking at the photograph on my wall, I find my paternal grandparents' house and shoe store at Number 962, one of many places in the neighborhood that shaped who I was and who I would become.

The Street, the Store, and the Home

In the 1930s, my parents moved around quite a bit, always just a few steps ahead of the landlord. The first of their four children, I was born in 1936, and for two years thereafter, we lived with my mother's aunt and uncle above their grocery store. This was when my love affair with Marshall Street began. My cousin Leonore, who was raised by my father's parents a few blocks away, would often babysit me after she got out of school. She would walk me up and down the street or take me to the shoe store and the apartment above it. From the time I was five or six, by which time we lived around the corner from Marshall Street, I went on my own to Number 962 to visit my cousin and grandparents.

I picture myself skipping up and down Marshall Street, saying hello to the pushcart people and the shopkeepers—the herring lady with her barrel of fish, the banana man, the fruit lady, the quilt lady, the corset lady, the potato man, the soda man. I have a cousin who was raised in a suburb who found Marshall Street frightening and dirty. I found only kind people, good smells, and something happening all the time. I loved, loved, *loved* this world, and I understand now how much it shaped my love of neighborhoods, communities, the working class, food, and fun.

Marshall Street residents raised their children in fairly spacious apartments above their businesses, sending them to the local public schools. If they went to college—and many did—it was typically to Temple University, an inexpensive commuter school not far away.

My grandfather's store, built a few steps up from the street, had a small display window in front. Inside the store, shelves reaching from floor to ceiling held the remnants of his shoe factory, lost in the Depression, as well as more up-to-date styles. I eventually tried on most of the shoes, from the high-button boots to the sandals that tied all the way up my calf.

In the back of the store was a stairway that led to the living quarters. The smell of leather permeated the apartment where my *zayde* (grandfather in Yiddish), my *bubbe* (grandmother), and my cousin Leonore lived. Heavy maroon and navy-blue mohair furniture dominated the small living room, which sat next

to an ancient bathroom. In the center of the apartment was the kitchen, where Bubbe spent much of her time. Unable to stand for more than a few minutes, she usually sat at the kitchen table making delicious Jewish and Russian food—chicken soup, borscht, gefilte fish, kugel, apple strudel. My father, Sam, used to stop over at his mother's for a "plate" of chicken soup and a taste of whatever else she was cooking, before going home to eat the dinner my mother had prepared.

Bubbe spoke only Yiddish to me, like my mother's parents. I understood her but answered in English. I couldn't avoid her sad eyes. A blond braid, fashioned years before from her own hair, was always pinned to the top of her head. She wore a black dress over her wide bosom, her overhanging stomach not completely controlled by the corset that my grandfather or Leonore tied tightly for her in the back. Bubbe sometimes let me do it. After bearing seven children, she had plenty to hold in. But she had shapely legs, like my father, Leonore, and me. In the bedroom next to the kitchen was an old blond chiffonier from Odessa with many little drawers. I liked going through Bubbe's pearls and brooches from her former life. She had a lot of jewelry, from what seemed like a hundred years ago.

On Fridays, Bubbe used to send me to a pushcart parked in front of the shoe store to get fresh horseradish to go with her gefilte fish. The woman ground the *khreyn* right there; its smell was so powerful that my eyes would fill with tears. I bought challah like the kind she knew in Odessa from a bakery down the street. Then I would stop at the dairy store next to the bakery to get farmer cheese and sour cream for blintzes. To my bubbe's list, I would add kasha from the Chalfins' store for my mother. I would also get a piece of my favorite sweet, halvah, cut from a large wheel like a cheese.

I also remember other little indulgences. I worked in my grandfather's shoe store from the age of nine, with my cousin Leonore and my father's youngest sibling, Uncle Al. On Saturdays, Al used to give me some dollar bills to buy corned beef sandwiches on rye with pickles and Cokes for supper in the store. Between customers, we bit into our sandwiches, beef fat dripping down our chins, while we listened to Frank Sinatra on the popular radio program *Your Hit Parade*. I

learned the American songbook from that show and especially loved George Gershwin's "Embraceable You" and Rogers and Hart's "My Funny Valentine."

Across the street was the tobacco store where Zayde would send me to buy the Philip Morris cigarettes that killed him twenty years later. In the middle of the block was a small synagogue. Zayde was the only one in his family who went to services, though not often. He would take my hand, and we would walk to Saturday service. I felt special sitting with my zayde, not only because he was a striking man but because when I was with him, I was allowed to sit in the men's section, while women and older girls sat looking down from a balcony reserved for the second sex. I was sorry for them, stuck up on that balcony, and even at a young age, I felt the injustice of this segregation. Later, when traveling in Europe or Israel, I refused to sit separately in that way—a legacy, at least in part, of my Saturday mornings with my grandfather.

Farther up the street was a dry goods store owned by my friend Elaine's parents. They also lived above their store. I used to play with Elaine for hours on top of the bolts of cloth they sold. A bit up from Elaine's house was a spot on the street where my mother's father, born Herschel Ladijhinsky but now called Harry Ladin, sold needles, thread, and other notions from a little folding table. He spoke only a few words of English, but Yiddish was enough for most people in our neighborhood. The non-Jewish immigrants from Poland and Russia often understood Yiddish. Black people from the neighborhood knew some Yiddish too. I would sometimes bring Zayde Harry bread and herring in a paper bag from my other bubbe, Golda. Around the corner, on Seventh and Girard, stood the Ambassador, a well-known Jewish dairy restaurant. Nearby was the barber that Zayde visited twice a week for a hair and mustache trim and a "nice shave" with a hot towel.

I keep a snapshot of my smiling paternal grandfather, taken when he was in his mid-fifties. He's wearing the white shirt and tie he usually wore. He looked very different from most of the Jews on Marshall Street, including his own sons. At six feet four inches and with a shoe size of 14, black hair, and olive skin, my grandfather looked like a Turk—he even had a red fez that I used to try on. He

could have been of any of several Turkic nationalities that lived in Vladivostok, where he was born.

My grandfather lived above the store on Marshall Street until he died of lung cancer in 1948. When he died, my father wrote him a letter of goodbye, which demonstrated a love that surprised me. They'd fought all the time. But it's clear in the letter, which I discovered in my father's writings after he himself died, that he felt very close to his father during his childhood:

> *A deep uncontrollable weeping rose from my innermost self and I uttered the word "Pop." If I could have been with you, to hold your hand, to make your pillows more comfortable. To tell you I love you. The smell of the medicines that permeated the hospital room affected my consciousness and my mind took me back to the Black Sea and Odessa. I was a boy again. My father and I walked on the shore as I played with him and brought him a hoard of beautiful seashells. The smell of the sea was in my nostrils and the fragrance of the flowers permeated the air. But I am a man, not a boy so long, long ago. I gently touched my father and kissed him.*

Marshall Street Redux

In 1983, I visited Marshall Street with my husband, Bill, and son, Josh, who was then a student at Swarthmore College, near Philadelphia. I hadn't been back in the old neighborhood since I left for college in 1954, and I felt a bit guilty about it. Even worse, by the time I went back, I found the street devastated, with gaping abandoned buildings, empty lots, and boarded-up stores. The synagogue had become a Baptist church. Most of the Jewish stores were gone.

An exception that cheered me up considerably was Goldberg's lingerie store, next to my grandparents' place. It was open on the Sunday we visited. A daughter of the Goldbergs, now a senior citizen, remembered me as a child and told me that her family used to call us "the Fighting Finkelsteins" because there was so much yelling next door. This wasn't a surprise; my parents had fought often and loudly. Still, I was happy to see that Number 962 was still standing, as

was the backyard ailanthus tree—the tree that "grows in Brooklyn" and, indeed, anywhere, even in a destroyed neighborhood.

Marshall Street and the neighborhood remained as we found it for a few more years until it was claimed by developers and the Philadelphia Redevelopment Authority, which rehabbed several row houses for affordable housing, including the by-then empty lot at 962. The synagogue/church was converted to apartments, and the surrounding neighborhood was rebranded as a hip place to visit.

My first reaction when I learned about this new Marshall Street was, *It's an awful idea*. But then I realized that the Marshall Street of my mind, the place where I felt most at home during the formative years of my life, was already gone by the time the developers arrived.

2

Glimpses of a Bigger Life

WHEN I STARTED FIRST GRADE IN 1942, MY PARENTS RENTED
a house in a neighborhood called Strawberry Mansion. It was the first time we
lived in a house, not an apartment. My mother's parents, Zayde Harry and Bubbe
Golda, moved with our family, which now included my sister, Nita, twenty-two
months younger than me, and my brother Harry, four years younger. Our grand-
parents helped my parents with us kids, getting up with the baby and taking my
sister and me to the park. They were quiet people. I hardly remember them and
need pictures to remind me of what they looked like. They must have been loving
and kind, because I was a happy little girl.

I was very proud of my shiny new "school companion," a box that held
sharpened pencils, an eraser, and a small ruler. I felt grown-up at my own desk
with my own teacher—and soon I had some girlfriends. When we were learning
to write numbers up to thirty, I invented a shortcut to get past ten quickly: first,
I wrote a bunch of 1s on each line and then I added 1, 2, 3, et cetera to the right
of each 1. When the teacher saw what I did, she scolded me.

I'd always been independent, stubborn even. As a baby, apparently, I already
had a mind of my own: my mother once told me that I really loved my bottle
and would scream loudly when I wanted it. She tried to get me to stop taking the

bottle, but I wouldn't give it up. One day, she got so angry that she grabbed a pair of scissors and tried to break the bottle with them. The scissors broke instead.

I could be fierce when I knew what I wanted and I would settle for nothing less. I loved dancing around the dining room table and asked my parents if I could take ballet lessons. Dad took me to a dance teacher around the corner, but when she turned out to teach tap dancing, I ran out of her house very upset. I wanted *ballet*. Even then, I somehow trusted myself to know what I wanted and to not be afraid to go for it. I would keep being stubborn, confident, and independent as I grew older––all qualities that served me well, except when they didn't. In the end, I never took ballet—and I probably would have enjoyed tap.

Our home in Strawberry Mansion was short-lived. In 1943, when I was seven years old, my family moved back to the old neighborhood—this time to Sixth Street, close to Marshall Street. We lived in an apartment on the second floor of a two-story brick row house; from the living room window, we saw the street below. I could easily walk to my grandparents' store and to my great-aunt and great-uncle's grocery. I transferred in the second grade to James R. Ludlow School, where the ambitious parents of Marshall Street sent their children. Besides the Eastern European Jews, there were Irish, Italians, and a few Black kids whose families had lived in North Philly for a while.

I don't remember anyone reading to me when I was little, nor do I recall any children's books around the house. But once I got to Ludlow School, I started bringing books home from school. I created a Saturday morning ritual, burrowing under my quilt with fairy tales while eating peanuts from the peanut man. Then I discovered *Let's Pretend*, a children's radio show that dramatized fairy tales with children playing the parts. Fairy tales showed me that I could transport myself anywhere.

When it was warm outside, I played war games with boys on the block. We were all aware of the war going on in Europe from our parents, who listened to the news every evening on the radio. And my father had told me about German concentration camps and the destruction of our family's world back in Europe. Sometimes a cousin of mine, Melvin Ladin, who lived across the street from us,

would play war with me and a boy named Norman. Norman was our age, around eight, but taller, so he always played a Nazi, while Melvin and I were fighters on the American side. I loved playing this game, because Melvin and I were on the right side and we always won.

At night, in bed, I would spin plots to kill Hitler. I would stow away on a big ship and when I got to Europe, I would jump onto a truck going to Germany and find Hitler and stab him. Or I would fly with American soldiers and parachute into Germany at night and slip into Hitler's headquarters to sneak up on him, saving some Jewish kids while I was at it. In my fantasies, I became someone who fought for what was right and saved people in danger. By age nine, just as the war was ending, I thought of myself as a hero.

Oxford Circle: Moving Up in the World?

In 1945, when I was nine years old, my father started a new business, the Aladdin Window Cleaning Company, whose customers were store owners in Northeast Philadelphia. My father asked us kids to suggest names for the business, but in the end, he came up with his own. Aladdin, who was a character in one of the fairy tales I heard on *Let's Pretend*, was protected by a genie who made him rich. My father hoped the window-cleaning company would do the same for his family. The name was a good-luck talisman for him—and it didn't hurt to have "Ladin" contained within it. I have no idea how my father made a living before this enterprise, during the Depression and war years. If someone else described him to me, I would say he was a luftmensch, a man who lived on air. His family used to call him "the dreamer."

In order to be closer to his customers, he decided that we would move to Oxford Circle. Without knowing it, we had joined the massive postwar migration to the suburbs. My dad rented an inexpensive house on Frontenac Street, which was filled with identical row houses with little lawns in front.

Even though it was nice to live in a bigger house, and though Oxford Circle was supposedly a step up from Marshall Street, I hated it. I missed my grandparents, my cousin Leonore, and my great-aunt and great-uncle with their grocery

store. I missed the shoe store and my old school. And most of all, I missed Marshall Street. Just as bad, inside our house, my family began falling apart. My parents fought more than they had in the past. My father yelled constantly about the chaotic state of the house and my mother's poor cooking—yelling that frightened Harry and Nita. As the oldest child, my responsibilities grew: I stood up to my father and yelled back. My mother, who did not have any friends and stayed home most of the time, sent me out to the store with instructions to take my brother and sister with me. And when my youngest brother, Ned, was born in 1946, and my mother couldn't cope, the baby's care fell to me. Even though I was only ten years old, I changed his diapers, fed him his bottle, and kept him entertained.

Maybe my parents' fighting was predictable. They were opposites. He grew up in a sophisticated city, she in a simple village. He went to college, she only as far as seventh or eighth grade. He was an Americanized immigrant, she still a greenhorn. He had blue eyes and light hair, she dark brown eyes and dark hair. Temperamentally, Sam was tempestuous and given to explosive anger, while Reba was quiet and secretive. Although my father courted my mother from time to time, taking her out to the movies, bringing her little gifts, it seemed as if she held herself back from him.

How they met is still a mystery to me. But in 1935, in the middle of the Depression, they had a modest wedding at a restaurant not far from Marshall Street. My mother was twenty-two, my father thirty-two. He had attended the University of Pennsylvania for a couple of years and was recently divorced with a young son. My mother and her parents probably saw my father as a good catch: fluent in Russian and Yiddish, educated, and from a good family. I still have no idea whether they loved each other. But when my father sang "Ochi Tzorniya" ("Dark Eyes") to her, a song containing both love and fear, my mother joined him.

Oh those gorgeous eyes

Dark and glorious eyes

Burn with passion eyes

How they hypnotize

How I adore you so

How I fear you though

Since I saw your dark eyes glow.

There was one bright spot during our time in Oxford Circle. On summer after-noons, my brother, my sister, and I used to bike over to Tookany Creek Park, about twenty minutes from our house. I came to know this park well and began noticing the weeping willow trees that dotted the landscape. I would lie under them, listening to their rustling and whooshing. Sometimes I would just lie on the grass, looking up at the sky and the clouds. I felt something then that I did not understand. It was a kind of joy and fullness that I didn't feel any other time, one I would feel again later in my life when I spent more time in nature. I liked that feeling but didn't have words to put to it. Still, some days it kept me going.

When we moved to Oxford Circle, I transferred to my third elemen-tary school, Carnell School, in the middle of fourth grade. When my teacher, Mrs. Laffer, gave me crayons and paper, I said something cheeky like, "What, no paints?" (We had just gotten paints at the Ludlow School.)

The teacher shot back, "What are you going to do, paint the school?" The class laughed, and I was embarrassed and angry.

It took me a while to get over this bad start, but the following year, in fifth grade, I was elected to the student council. I also wrote a Thanksgiving play that took place in an idealized New England family; I played the mother and discov-ered I liked being on stage. Later that year, I played the piano in school assembly.

By establishing myself as a school leader, I managed to create a place for myself as the smart girl who didn't fit into the class system of Oxford Circle—because of course there was one. The adult residents of Oxford Circle, most of them Jewish, created an unspoken class system based on the size of their houses, the donations they gave to the synagogue, and the clothes they wore. The girls perpetuated this system even down to the junior high students. While I became a leader *in* school, I was definitely not a leader outside of school. My relationship with the popular girls was mixed: they often invited me to their birthday parties,

but when I went, I'd hang out with their mothers and help clean up after. I didn't want to risk being rejected by the girls in that social group and knew their mothers would be nice to me. While I couldn't afford their clothes, I created my own outfits that looked pretty good.

Although I was trying to fit into the dominant culture of Oxford Circle, I held on to the values of Marshall Street. When the Jewish girls in my class bullied an overweight non-Jewish girl named Hazel, I started a group that did things together, like trick-or-treating on Halloween, and invited Hazel to join us. This is what I would have done in the old neighborhood.

In sixth grade, I made friends with Shirley and Estelle, intellectual girls who were not part of the social girls' scene. We walked each other home from school, back and forth several times in one afternoon, talking about everything and everybody. We would escort one friend to her house, and then that friend would offer to escort us to ours; this could go on for an hour. Spending time with Estelle and Shirley helped me develop a new sense of myself—the first step in constructing a life away from my family.

At home, I busied myself with learning the piano. I had begun piano lessons when we lived on Sixth Street, but I met my dear teacher Grace McGinley after we moved to Oxford Circle. Miss McGinley came to my house every week from the time I was nine until I was fifteen; soon, my father talked about my becoming a piano teacher when I grew up. I understood that he was thinking about my future ability to make a living but didn't want that career. It seemed too much of a compromise for me—not that I had other ideas at that point. Miss McGinley was a fine teacher, and I am grateful that she introduced me to the important works in the piano repertoire: Beethoven's "Pathétique," the Bach two-part inventions, Brahms, and Mozart.

She also ventured outside the standard repertoire to introduce me to Debussy. I had heard jazz but never knew that classical music could be so jazzy. I have no idea why Miss McGinley introduced Debussy's work to me, since he was so far outside the classical canon. *Was he one of her favorites?* In any case, I responded immediately to his lush harmonies and complex rhythms and have

been playing him ever since. I had developed considerable technique playing the masters, so I could play Debussy without the usual muddiness and schmaltz that some people associate with his music.

In junior high, I continued to develop a sense of my identity, though of course it was shaped by my previous experiences. Woodrow Wilson Junior High School, a bus ride away from my house, opened up a world very different from elementary school, and in more than the usual way. The junior high was an old school building where the principal had created a high-level academic environment; paintings adorned the institutional green walls of the school. I recognized in those paintings a subtle message: this was a special place. I recently learned that a former principal at the school had acquired what later became valuable paintings by Thomas Eakins, Henry Ossawa Tanner, and Walter Baum, among others.

I had a wonderful time in junior high. As in elementary school, after a year, I was elected to the student council. I attended Friday night dances at school, where I learned to jitterbug and practiced the latest steps to the rumba and cha-cha. After those dances, I would jump into a booth with friends at a hamburger joint called the Hot Shoppe on Castor Avenue, the main drag in the neighborhood. It was about as close as you could get to the wholesome teenage life that's been portrayed as typical of the fifties.

On Saturdays, I took a bus and a train to work at my grandfather's store on Marshall Street, where I earned about $5 for the day, money I spent with my friends on Castor Avenue. I had worked at my grandfather's shoe store since age nine, putting away boxes, cleaning up, and running errands. By the time I was about twelve, my grandfather finally let me wait on customers. I found it thrilling to help the customers find something nice. I didn't like putting the shoes on their feet but I did like trying to help them find something they liked. It was a game to me. Could I find something that would please them? How many sales could I make? I was proud of remembering so many shoe styles.

Dipping into Judaism

Some Saturdays, without telling anyone, I went by myself to a beautiful Conservative synagogue not far from our house in Oxford Circle. I had read Anne Frank's *The Diary of a Young Girl* around that time and was shaken by the story as only a twelve-year-old can be; I'd cried and cried. At the synagogue, I joined the youth group and took Hebrew lessons from the cantor's Israeli wife. When we sang the Shema, the Jewish prayer about the oneness of God, tears would catch me by surprise.

I never told my parents that I had joined Temple Shalom. I knew that they would not approve, even though as a child I did not yet understand the nature of their disapproval.

Only later did I come to see that my parents had their own reasons for avoiding religion. My father, for his part, fully embraced his cultural Jewishness, if not Judaism itself. When he went to the University of Pennsylvania, at a time when the school had a quota for Jews, my father had worn his Jewishness proudly. A freethinker and left-winger, he thought of himself as a political and a cultural Jew who loved Yiddish literature, especially Sholem Aleichem, and Yiddish theater, which was staged by several active troupes in Philadelphia when I was a child. He was involved in secular Jewish organizations, including the Jewish Labor Bund, a socialist group.

Dad talked often about Odessa, which he'd left at age nine, in 1912. He spoke about the magnificent city itself and about the family he'd left behind, though he did not focus on the 1905 pogroms, in which more than two thousand Jews were murdered, or on his grandfather, who had been sent to Siberia for some unknown reason and amount of time. As far as I know, my father's devotion to Odessa did not express Jewishness. He did not go to synagogue, nor, as far as I know, did he pray—or maybe he didn't know how to pray.

My mother, unlike my father, did not advertise her Jewishness at all. Raised in the early years of the Soviet Union, she had witnessed a pogrom in her village that forever shaped her conviction, that being Jewish was dangerous. While she was reluctant to speak about her family in Ukraine and what her life had been like

there, I knew that something awful had happened in 1917, when she was about four years old. Only once, when I was in my late forties, on a nighttime drive with my mother and my husband, did she tell me about a little girl whose family lived in her village. I can almost hear my mother's emotionless voice as she spoke.

"I remember a little girl who was at home with her mother when the soldiers came for the Jews," she began. "Her two sisters were at school. Her father ran to hide in a haystack covered with snow. Her mother hid her under her skirt and then pushed her away and told her to run to the neighbors, who were not Jewish. She ran away and left her mother. The neighbors hid the little girl from the soldiers."

"Were you the little girl?" I asked after a few minutes of silence.

She did not respond. Instead, she said, "The little girl didn't know what the soldiers did to her mother. Her mother had headaches for the rest of her life."

When she finished, Bill and I tried to comfort her. But she resisted, continuing to claim that the story belonged to another little girl. I could imagine my mother as a small child witnessing those horrors. I believe they held the key to my mother's personality and it broke my heart.

In America, my mother seemed more comfortable with people who were not Jewish. While she spoke Yiddish to her parents, relatives, and in-laws, she felt more at home in Russian. And she dated several non-Jews after she and my father got divorced. I also imagine that my mother's experiences at such a young age must have indelibly shaped parts of her personality and beliefs about the world, including her secretiveness and her tendency to suppress emotions.

And so, both my parents were shaped by a history of loss and fear, even if they responded to that history in different ways.

Much later, in the late 1990s, I hired a genealogical researcher in Ukraine named Alex to learn more about the family my mother had left behind. For months, he found nothing, until one day, in a phone book, he came upon a woman named Emma Ladijhinsky, whose grandfather had been my grandfather's brother. Although her grandfather's story was dreadful––he was killed in 1941 by the invading Germans, because as the manager of a sugar beet factory, Alex wrote, "He did not order the local peasants to plant enough sugar beets"—I felt

like I had won some kind of macabre lottery when I learned about Emma. I was full of joy. Finding her seemed fated.

In July 2006, I received a long email in Russian from Emma, which began, "Hello Zelda, my dear unexpected relative, greetings to you from my beautiful land that was a cradle of all those whom we remember today with sadness."

Emma went on to explain that her father was drafted into the Soviet army on the first day of World War II:

> When [the] Germans came our neighbor-turned-policeman threatened us with arrest. My poor mother escaped with two small children in hand, my sister and me, attempting to save us. That's how we found ourselves sixty km from our native place in the small village of Ivanovka of Voroshilovgrad region where we stayed through the war until the arrival of our troops in the fall of 1944. I have remembered all my life that early morning when the village was put on fire, our infantry in gray overcoats were running through the kitchen garden chasing German troops who retreated during the night. From every side you could see the fires of the villages that the Germans burned and realized that it was happening everywhere. From things we saved from the burning house we put together some kind of bed; burning chips were flying over our heads. Forget about sleep, we never closed our eyes until the morning. At that time, I was just a few months past seven years old.

At the time of our correspondence, Emma was sixty-nine years old, and I was seventy. I felt immediately that I could have been Emma, watching my town burn and fleeing for my life. She could have been me, having a safe, normal childhood in Philadelphia. Her warm letter read as if we had known and even loved each other all our lives. I wrote back, expressing my sadness about the hardships she and our family suffered, but I didn't hear from her again. Then in 2010, four years after her letter, her son wrote to tell me that she had died. Though we had never met, I was devastated, as if I had lost a dear sister or friend.

Loretto Avenue

After renting three houses in Oxford Circle, in 1950, my parents bought a house at 6049 Loretto Avenue. I was fourteen years old. The house sat in a section of older, slightly larger row houses and had a sun porch, a tuft of grass in front, an attached garage, and a finished basement. This was the first "avenue" we had ever lived on. I liked the sound of "avenue" compared to the run of the mill "streets" we had lived on before. Buying Loretto Avenue, after renting or living with relatives for the first fifteen years of their marriage, brought my parents together. Fixing up the house became a family project, while we watched the painter brighten the walls with new paint and the paperhanger hang the pink-flecked wallpaper I had picked for the room I shared with my sister. I thought that our room looked like a typical girls' room of that time—not quite like the pictures I saw in magazines, but nice—and I loved that.

In the basement of our house on Loretto Avenue, I would practice every day for hours on the used upright piano my father found for me. My younger brother remembers how my playing filled the house with music--endless scales that apparently drove everyone crazy, as well as real music. In that basement, I created a room of my own, much as I have today, with a piano and a desk, a chair, and my favorite pictures and knickknacks. It was a place for me to get away from my family without being questioned.

When I was about fifteen, Miss McGinley said I had gone beyond what she could teach me. From then on, I went to see Leo Ornstein, a Ukrainian who headed a music school near Rittenhouse Square. He was a talented performer and avant-garde composer, known for his angry, dissonant music. I have often thought that my future husband, Bill Gamson, must have played kickball in the alley behind his house on Rittenhouse Square as I passed on the way to my music lesson.

Getting to the music school was half the fun. My routine was to take the bus from Oxford Circle, then transfer to the elevated train to downtown and take another bus to Nineteenth and Spruce. I would dash to my lesson, and afterwards eat lunch at the soda fountain at the corner drugstore—always the

same meal: an egg salad sandwich and a Coke. Or I would walk farther down to Chestnut Street to a Horn and Hardart, a popular automat, where I would reach into little compartments with glass doors for creamed spinach, Harvard beets, and cooked carrots.

Choosing my food and eating it alone brought me great pleasure—not only on those afternoons at Horn and Hardart but throughout my life. At home, to escape from the mess and noise and anger of my family, I would eat nuts in bed while listening to *Let's Pretend*. Many years later, when I was married, I would return to a version of this mood, retreating to my bedroom after an exhausting week to read a novel, maybe with a bowl of ice cream, and take a nap. I called it "Taking Care of Zelda."

Opening the door to the Ornstein School of Music, I was greeted with a blast of sound, a mix of sopranos practicing scales, basses singing in Russian, and students of piano and violin playing from different scores. I loved it!

Ornstein's studio was a cavernous space, with two grand pianos standing next to bright windows running from the ceiling to the floor. To get to the pianos, I would walk in semi-darkness across yards of Oriental carpets. Ornstein himself was dwarflike and swarthy, with wild hair and an impatient manner. Even to sit down at one of the grand pianos, I had to overcome my timidity. When I played for him, it wasn't long until he corrected me. "Stronger, stronger," he would shout when I would play a Beethoven concerto. "Don't play like a girl!"

In the few years I spent with him, I mastered some very difficult music, yet I never felt I was good enough. Still, I've kept my old scores––even the crumbling ones. Across from the shelf where many of my family photos sit, I have a small keyboard and a basket of music that I used to play. I've carried this music with me as I moved to college in Yellow Springs, Ohio; to the University of Michigan, in Ann Arbor; to Cambridge for graduate school; back to Ann Arbor; to Boston and Martha's Vineyard; and then to Brookline. Some of the scores have "Zelda Finkelstein" and "6049 Loretto Avenue" written in my teenage handwriting.

The summer after we moved to Loretto Avenue, the director of a camp for underprivileged girls offered me a job as a junior counselor. I welcomed the

chance to get away from home but had a hard time there at first. I had gone to the camp when I was ten—as an underprivileged kid myself—and this fact seemed to mark me with some of the other counselors, who came from upper middle-class families. A few of the Jewish counselors, in particular, looked down on me. But not all. I became close friends with Ellie, a sweet Jewish girl from a small town in the middle of Pennsylvania. I realize now, that I felt humiliated at the time about being considered "underprivileged"—something I had never felt before.

I also had to put up with a bit of teasing about my name, which was the butt of jokes on the popular Milton Berle show on TV. Zelda was a Yiddish name, and Berle, though he was Jewish himself, liked to poke fun at such stereotypical Jewish names. My fellow counselors, in a show of concern about possible teasing from the campers, suggested that I change my name to "Zee," a nickname that has stuck with me for the rest of my life. I feel quite gleeful to learn that "Zelda" is back as a cool name for babies among those who know nothing about its Yiddish roots but do know all about the video game series, *The Legend of Zelda*.

Around that time, I developed a habit of cleaning the mirror over the sofa in the living room after I got home from school. Window spray and paper towels in hand, I took great satisfaction in making the mirror sparkle. It produced in me a sense of order and calm when the rest of the house was a jumbled mess. I didn't feel, as I would in later years, the need to clean up the entire house. The mirror would do.

My family lived on Loretto Avenue for the next twenty-five years, through high school graduations, my departure for college, and my parents' divorce.

In tenth grade, I moved on to Olney High School, which was a short bus ride away from Oxford Circle on Roosevelt Boulevard. I hung out with the smart kids, both boys and girls. For reasons I can't explain, Shirley and Estelle were not part of this crowd. I became close to George, a boy from a conservative German Lutheran family who was concertmaster of the Olney High School orchestra. Several students, including me, took turns playing the piano in the orchestra. Another new friend and confidante, Chelly, came from an upwardly mobile Jewish family who lived in a tidy suburban neighborhood. I would often go home after

school with Chelly to her pretty, orderly house. Her mom wore an apron and cooked for us. My mother was definitely not that type, and I knew that *I* didn't want to be a mom who constantly cooked and wore an apron, but I'll admit: it was nice to be on the receiving end of this kind of nurturing.

I excelled in high school, getting close to all As and winning a prize for my mastery of Spanish. I was definitely cut out for the humanities and took AP English. I made it into the honors society and sat on the student council and, in my senior year, was editor of the yearbook.

On the weekends, I went on dates to the movies, dances, and pizza parlors. I met Joey, a handsome grad student six years older that me, in Atlantic City on a family vacation when I was fourteen. He was a serious student of general semantics, which he taught to me. (Nine years later, I felt drawn to the study of language, perhaps an expression of Joe's tutorials.) I never really thought of Joe as a boyfriend; he continued to show up over the next five years, visiting my family and even meeting my eventual husband.

For the most part, the boys behaved well, getting me home on time and leaving me with a peck on the cheek or a light kiss on the lips. There was one notable exception: Billy. My crowd of smart kids were shocked when I began going out with him. I met Billy in my junior year at Olney High School. Billy could have stepped off the streets of Italian South Philly. A good-looking kid who stood a few inches taller than I was, Billy wore his hair long and slicked back into a "DA" (duck's ass). He smoked and kept his cigarettes in the rolled-up sleeve of his T-shirt à la James Dean. He drove to high school in a green Chevy convertible. One day after school, he picked me up in his car. To the astonishment of the studious friends with whom I was standing, I walked over to the convertible, opened the door, and got in. No one else I knew had his own car, let alone a convertible. Why did I go out with him? Well, the convertible. He was cute. And for the whiff of danger he carried.

Then he became a bit frightening. We'd pull over and kiss in his car, but kissing wasn't enough for him. When my usual techniques of deflecting

advances—telling him no and batting his hands away from my chest, even slapping him—failed, I stopped answering his phone calls.

I was a cute girl with a round, Russian face and blue eyes. I had no trouble fitting into the gender roles of the 1950s dating culture, in which the boys asked the girls to go out, picked up and dropped off their dates at their houses (often so as to be looked over by her family), and paid for everything. Sexual activity went no farther than "petting"—in those days before the pill, girls were very wary of going "all the way," even when they wanted to, for fear of getting pregnant. We girls had to establish firm limits about how much touching we would allow. I resisted going steady and went on two or three dates every weekend, trying to have fun but not getting seriously involved with anyone.

I had several dates with a nice Jewish boy, Marty, who went to Central High School, a selective public high school for boys. He invited me to go to his prom. I managed to borrow a gown from an older girl who was my size, but I didn't like the dress, and when I returned it, I promised myself that for my own senior prom, I would get the most beautiful dress I could imagine. When the time came, I saved money from my jobs at the shoe store and a Sunday school to buy myself a pale blue silk gown from a boutique on Walnut Street, near my music school. I asked the saleswoman to put away the dress, and every two weeks after my lesson, I paid $5 toward the $85 of its cost. That's $868 in current dollars—a lot even for a wealthy teenager! But as I would continue to prove time and time again, when I wanted something, I became bent on making it happen. And I wanted that dress. Though I don't think I ever wore it again, for years afterward, I loved looking at it in my closet. To remind me of it now, I can dwell on a prom picture taken of me with my date, a sweet-faced boy named Dave. I have forgotten him, what music we danced to, or what we did afterwards. But I'll never forget that dress.

The Ivy League

When I was little, I thought the most wonderful thing in the world was to make mud pies. I loved getting dirty and smooshing the mud around in my hands. When people asked me what I wanted to do when I grew up, I would say, "I'm

going to go to college." And why did I want to go to college? "To make mud pies." Somehow I got the idea that college was a wonderful thing—and that it could only mean making mud pies.

So I knew, from an early age, that I wanted to go to college. But where I would go was a different story. I didn't even know how to figure out my options. Luckily, in my junior year, Miss Vogt, who taught AP English and advised the yearbook committee the following year, when I was editor, got me started. "Have you thought about where you want to go to college?" she asked me. "Not really," I replied. "There are many different colleges you might be interested in, so you should speak to Mrs. Gratz, the college counselor. She can help you." When I found out about the different colleges Miss Vogt was talking about, I thought I'd like to be in New York—a women's college like Barnard appealed to me. But it charged more than I knew my family could afford. At the time, I didn't even look into whether I could get a scholarship to Barnard. I thought I would have to go to college in Philadelphia. Something told me to not go to Temple, where most of my college-going Olney classmates were headed. It seemed like high school all over again, and I wanted something different. What that would be, I didn't know.

When someone mentioned the University of Pennsylvania to me, I jumped at the chance to apply. I was accepted for admission in the spring term of 1954, since I had graduated from high school in the middle of the year. Somehow, I landed in an Ivy League school, though I didn't know then what "Ivy League" meant.

I liked being on a real campus with old buildings and an academic atmosphere. I loved the library, where I did all my studying, since I lived at home and had to take several streetcars to get back and forth every day. Tuition was $800 a semester. Based on my rank as third in my graduating class, I received a $400-per-year, four-year scholarship from the Philadelphia Board of Education. I asked my parents for another $400 a year, something they could ill afford. In fact, at a couple of points during my college years, I was on the receiving end of an embarrassing call from the financial office, saying my father was behind on payment. The Aladdin Window Cleaning Company produced an unpredictable income.

For the most part, the classes at Penn were badly taught. Introductory sociology was a joke. The lecturer droned on about ideas that were obvious to me, like the existence of different social classes and different cultures. But I loved intermediate French and was impressed by the French woman who taught the course. When I wrote papers in French, I discovered a new personality—expressive, philosophical, funny. Busy as I was, I also ran around joining clubs, including the drama club and the French club.

Social life at Penn was built firmly on fraternities and sororities. It wasn't long before I was pulled into it. The Jewish and non-Jewish fraternities and sororities did not mix, so I went out with boys from the Jewish frats. My prom date at Central High, Marty, invited me to parties at his frat and the boys seemed to feel they had the right to some sexual favors. They were disrespectful of girls, especially those they called "townies," who were usually not Jewish and seen as "easy."

All in all, my time at Penn led me to feel constantly drained of energy. I found the frats repellent, the clubs I joined meaningless, and the classes lackluster. I especially disliked commuting. Not only did I spend an hour each way on public transportation, but when I got home, I was thrown back into my increasingly dysfunctional family. My father seemed more agitated, my mother more withdrawn. Between my family falling apart and my disillusionment on campus, it's no wonder I was exhausted and unhappy.

At the time, though, it seemed I had no alternative.

Then I got lucky.

At the end of my first semester at Penn, I was studying for finals when I bumped into Maida, a girl I didn't know well. She told me that she was transferring from Penn to Antioch College, located in a tiny Ohio town called Yellow Springs. I had never heard of Antioch and learned from her that it was really different from Penn: a small liberal arts college with a good faculty and a cooperative education program that required students to work at real jobs half the year and to study the liberal arts the other half.

I seized on Antioch immediately. I said goodbye to Maida and looked up the Antioch catalogue in the library. The question was whether I could afford

to pay for tuition, room, and board: at that time, total costs at the college were $1,200 a year. I calculated that with my Board of Education scholarship of $400 a year and the additional $400 that my parents paid for Penn's tuition, I could afford Antioch if I saved another $400 from my co-op jobs, plus a bit more to cover travel and spending money.

I was surprised that my parents did not stand in my way—in fact, they actually encouraged me. My father may have seen Antioch as a chance for me to carry out his dream of living in a righteous intellectual community, my mother as a way to set me free. I even wonder if it was part of what inspired her to seek her own freedom from my father. After almost twenty years of marriage, they separated in less than a year after I left home.

I stopped studying for finals at Penn and applied immediately to Antioch. I was admitted a few weeks later and saved as much money as I could from a job in a shoe store I had lined up for the summer. I used these savings for a plane ticket to Dayton, Ohio. My whole family—mother, father, sister, and two brothers—drove me to the Philadelphia airport. I was exhilarated but anxious. I felt as if I was parachuting into a tiny dot on the map, and who knew if I would get there intact and who knew what it would be like. To cover all possibilities, I was dressed to kill; in those days, people dressed up to travel. I had curled my hair the night before and wore a billowy blue-and-white checked dress with a tight bodice and a full skirt that had a puffy crinoline underneath.

At the airport, my brother Harry surprised me by handing me a pair of his "dungarees," as jeans were called then, saying he thought I might need them. In 1954, girls didn't wear pants at all, let alone dungarees, and I've often wondered what led Harry to give them to me. Then, as I was getting ready to walk onto the tarmac to board the plane, Harry also gave me $14 from money he had saved up over the summer.

As it turned out, Harry had the right read on Antioch, which was a full decade ahead when it came to girls' dress: more sixties than fifties. I went from never before having worn dungarees or slacks to wearing them much of the time; I liked how comfortable they were and how they looked. I saved my skirts for the

co-op jobs I'd do in the years to come. For the first time, I learned to code-switch, but it was far from the last.

3

Finding My School, Finding Love

A SMALL BUS MET ME AND OTHER NEW STUDENTS AT THE Dayton airport and drove us through farmland to the village of Yellow Springs and onto a lovely, green campus in the middle of town. I was assigned to North Hall, a women's dormitory close to the classrooms and across from a stately administration building. I dragged my large suitcase to the second floor of North Hall, where I met my roommate, Mary Ann.

She was a plain and shy, dark-haired girl with sharp eyes and a ski-jump nose. She fled when she saw me. Looking around at how the girls were dressed, I realized that Antioch was a place where girls didn't need to fix themselves up. I could lose the curls and the crinoline dress.

The next day, I washed out my hair, put on my brother's dungarees—which magically fit—and bought an Antioch College sweatshirt at the college bookstore. I wore the sweatshirt inside out, setting some kind of a trend. This became my uniform for the rest of my time at Antioch.

After this transformation, Mary Ann and I became friends. From a family like mine, with limited means, she was brilliant in math and passionate in her opposition to the Catholicism in which she had been raised. I was impressed

by her strong opinions about religion, since I had not been exposed enough to Judaism to form an opinion about it. We soon began talking, and talking, and talking. From our very different backgrounds, we educated each other.

Home at Last

It didn't take me long to feel at home at Antioch. The minute I stepped onto campus, I felt a great relief; it was all somehow familiar. *How could that be?* I now wonder. I had never seen a small college, nor had I traveled beyond Pennsylvania. In 1954, Antioch was one of the leading liberal arts colleges in the country, but in pamphlets I picked up in the library, I learned that the path to that position had included financial difficulties, utopian ideals, and an instinct for survival. Could I somehow sense that my own family's struggles and my father's ideals were reflected in the history of Antioch? All I knew with certainty was that Antioch was for me, and I was grateful for it.

While Antioch felt like my new home, I was still a little homesick for my family. A few weeks into my first academic period, I received a letter from my mother that pulled me back to Loretto Avenue:

> *Please forgive us for not writing to you any sooner. We were all waiting for Daddy's (real estate) sale. The deal fell through. We were very disappointed. Now it seems that I'll not be able to come to visit you. The car is not in good condition.*
>
> *You used to say Mommy. Now you call me Mom. So don't forget anytime you need something you know whom to ask. I will only be too glad to help.*
>
> *—Mom*

I remember crying when I read these words from my mother. She wasn't given to expressions of affection; I didn't remember the last time she had hugged or kissed me. These words were the warmest, most loving words I had heard from my mother in a long time.

One thing I concluded from my mother's letter: I had to figure out a way to earn some money, and fast. About $25 from my summer job, plus $14 my brother gave me, would not keep me in shampoo (when I ran out a bit later, I simply used the soap in the group shower room) and books. I found a job as a hostess at the Antioch Tea Room, which served a country dinner on Sundays. The waitressing jobs with the best tips were already taken, but the job of hostess, which paid $5 an hour, was open. I scooped up as many Sundays as I could and took out the simple black cotton dress I had packed for co-op jobs.

Around the same time, I received a letter from my father, with a very different tone than my mother's letter. He wrote:

> *Please, tell me all that you can about Antioch College—the kind of student body that it attracts, and how they spend their leisure time, study habits, teachers, courses, and how it develops the personalities of the student body as a whole. There, in the cloistered walls of the college, is there a genuine atmosphere for the love of learning in itself or rather the returns it can bring in prestige? Write all about the college in general and specifically. I hope you are well and happy.*
>
> *—Dad*

In that letter, you can feel my father's intellectual aspirations to teach and to write; I have often thought that Antioch was a place where he would have thrived as a young leftist. He would have been furious to know that the FBI watched the college closely, and that several faculty members were served subpoenas to testify before the Ohio House Un-American Activities Committee investigating communism on campuses. And he would have been impressed by President Douglas McGregor's successful defense of the educational value of academic freedom, which got the Ohio HUAC, if not the FBI, off the college's back.

Though I don't have my response to my father's letter, I probably would have told him about the political leanings of the faculty and students and the unique culture of the school. Antioch and Yellow Springs were progressive, even utopian oases within conservative Middle America; the college was a magnet for left-wingers, nonconformists, and artistic types. Among the students the

college attracted were sophisticates from New York, often Jewish, and political activists from Communists to Quakers, as well as down-to-earth future engineers, businesspeople, and teachers who came for Antioch's work-study program. The faculty reflected this diversity of backgrounds, creating an atmosphere of openness and tolerance.

In stark contrast to Penn, the college rejected fraternities, sororities, and extramural sports. Social life was built around radical politics, folk music, and avant-garde art. Performances by artists were common on campus, and they were a source of learning as important as formal courses. Almost immediately, I was introduced to "Red Square," the place where folk singers, like Pete Seeger, gathered. I learned about contemporary music from John Cage and other avant-garde musicians.

As my father had hoped, the faculty and students at Antioch took learning seriously. When I transferred to Antioch, in the fall of 1954, I was told I would get credit for all of my courses at Penn, some of which fulfilled requirements at Antioch. I signed up for a mixture of required and elective courses as a second-semester freshman, taking courses in English, geology, philosophy, and mathematics. All of them were taught by senior faculty—all men—who took the time to talk to us and comment extensively on our papers. Now, when I read my old papers from that time, written on onion-skin paper and crumbling in filing cabinets next to the desk where I write, I see clearly that Antioch played a defining role in shaping my thinking. And I see my younger self, a self-possessed young woman who is exploring her mind but is not yet sure of what she thinks.

While the community exposed me to the avant-garde and progressive politics, the academic side of Antioch shaped my brain. I discovered that I understood aspects of literature and philosophy without having studied them. I didn't know how I knew, for instance, about how language works or what constitutes ethical behavior. The college's faculty taught me how to access intuitive understanding and bring it out with clarity and discipline.

Antioch required a lot of writing. My first paper, dated a few weeks after I arrived, was for a required English course on a subject I remember at first finding

tiresome: "The Influences of the Celtic, Roman, Anglo-Saxon, and Norman Conquests on the English Language." Although I was not interested in the philological approach, language in general was to become one of my abiding interests. I started the paper like this:

> *A mammoth task for a short, five-week period! The influences of the Celtic, Roman, Anglo-Saxon, and Norman conquests on English had so many ramifications that, upon deciding to undertake this study, I was somewhat bewildered as to how to treat the material. I could have developed a thesis on any one foreign influence. I might have considered the influence of the conquests on modern English exclusively. On the other hand, the character of the words incorporated into English could have suggested a psychological study.*

> *But all of these considerations seemed futile. How could I write a paper on these rather specialized topics when I knew, basically, nothing about the subject?*

> *So I decided to start from the beginning.*

And I was off and running. When I started the paper, I thought I had nothing to say. But as I wrote about the prehistoric origins of English, I became fascinated with the diversity of languages that later formed the one I spoke. In this and other papers from that period, I see myself trying on different styles of writing, often imitating what I was reading. Nonetheless, I seemed to be able to voice my own ideas and feelings about the subject matter.

The last paper I found in my files is dated June 1, 1956, for a humanities course taught by the mathematician Gus Rabson. The paper is entitled "On Truth." By this time, I had discovered the concept of relativism and was drawn to it, but I wanted to reconcile it with truth. In the paper, I struggle with the loss of absolute certainty but conclude that we cannot say everything is relative either.

> *The relativistic view allows for a great deal more freedom of inquiry, and yet it recognizes that man's judgments about the world are his own, not extracted from the essence of a "thing" out there. This, too, is truth. In a sense, man can't get out of his head . . . We must learn*

to live with the imminence of uncertainty, not only in science but in
morals, but this does not undermine present truth.

I was becoming a philosopher. I explored this interest further in another course, the history of philosophy course taught by George Geiger, who had been a student of the reformer and philosopher, John Dewey. I loved being able to focus intensely on *how* to think and track the way an idea could be approached in different ways by the same thinker or by several philosophers living in different times. I especially felt drawn to the study of ethics and aesthetics, in the hope that I could discover the meaning of life—or at least the meaning of *my* life.

History of philosophy was an upperclassmen's course. As an underclassman, I was afraid to speak in class. One day, a senior majoring in philosophy told me Geiger had said that even though I didn't talk in class, I was writing good papers. I walked on air for several days after hearing that.

I received good grades in most of my classes, as well as praise from some teachers. One faculty member's comment on a government paper I wrote in March 1955 read, "Your paper is a real compensation for the tedium of reading most of the others. No other paper demonstrates such a clear understanding of what lies behind the government's changing relationship with the economy." When I read this comment recently, I thought, *Wow. I was good!*

In my second year at Antioch, I declared philosophy as my major. My admiration of Geiger, as well as the readings and papers, reached something deep within me—and freed my mind while helping me develop discipline and analytic skills. It didn't hurt that some of the most interesting students at Antioch were studying philosophy.

Beyond that, my two years at Antioch freed me from the limitations of my background as a lower-middle-class Jewish daughter of immigrants, without driving me away from those roots. Antioch showed me that a life of meaning did not depend on wealth. I learned that I had a good mind and developed the confidence to take on difficult intellectual tasks. That turned out to be enough for me.

Enter Bill

Although the student body was liberal-minded when it came to politics, the Antioch community still abided by the sex and gender roles of the fifties. There was only one woman on the faculty, and she was more of a counselor than a professor. Men held all of the leadership positions in the administration and in student government. If there were homosexuals at Antioch (and there must have been), they were closeted. There were dances similar to the ones I attended in high school, where the couples were strictly boy–girl, and boys would ask girls to dance, but not vice versa. Like the fraternity men at Penn, upper-class boys at Antioch rated incoming freshman girls on the size of their bust and—because it was Antioch—on their test scores. Antioch men, including a few professors, thought it was their due to have sex with female students. Girls often dropped out to follow their boyfriends to graduate school or a job, but not the other way around.

There was one opportunity for girls to take the initiative socially, and that was Sadie Hawkins Day, when girls could ask boys out on dates. In the spring of 1954, I decided to ask out a boy on Sadie Hawkins Day—something I had never done before. But whom? I had a few choices. There was my distant cousin, who was a graduate student at a nearby university and had come to visit me several times. There were several boys I had dated casually: Dan, from New York and a bit of an intellectual snob, was an aspiring writer. Marty, a funny boy from the Bronx, had just left for a co-op job. Then there was a guy I had noticed several times in the library—Marty's former roommate, with auburn hair and a sweet face. He was a senior, and his name was Bill. He intrigued me because he was self-possessed and studious. He and I had never talked or even exchanged glances. I had no idea if he had even noticed me. That was fine with me—I just needed someone to go to the dance with me, not a boyfriend.

I went up to Bill in the library one day and asked if he wanted to go to the Sadie Hawkins Day dance with me. He looked surprised but said yes. The night of the dance arrived and we met at the building where it was held. Dancing with Bill was awkward because, like other middle-class boys those days, Bill had

been sent to dance classes and had learned to do one routine—if it can be called that—the box step. And nothing else; I, on the other hand, could follow any step and initiate some of my own. I could dance the rumba, the cha-cha, the jitterbug, also the oldies, the polka and the waltz.

It wasn't fun having to follow Bill, and I soon decided it was a deal-breaker. I couldn't imagine going out with him again. Ten or more years would have to pass until rock and roll would change the dance floor, freeing me from having to "follow" a man's "lead," which most men felt uncomfortable doing anyway.

After the dance, Bill and I walked around campus talking about Philadelphia, where we both grew up, and decided we might have been at the same prom at Central High School. We also realized that I passed close to his parents' row house on Rittenhouse Square on my route to the Ornstein School of Music. Despite his graceless dancing, he surprised me with his easy sense of humor. He charmed me by singing all the verses to songs by Rodgers and Hart, like "Bewitched, Bothered and Bewildered" and "Mountain Greenery." Despite listening to Frank Sinatra on *Your Hit Parade*, I knew only a few of the songs he sang. He sang them adorably, just for me. And I loved the attention. It was a Saturday night, and our faces must have been glowing in the light of the Victorian lamps that lit the paths through the Antioch campus.

I wasn't looking for a regular boyfriend, but I found myself drawn to Bill. He was obviously smart and creative. He was fun. What made him different from other boys I dated was that we could talk about anything—like friends.

From that time on, we were inseparable. We studied together. Antioch required hard studying, something I was used to doing. It was different for Bill because he entered college after a lackluster academic record at Central High, where he spent more time serving as the sports editor of the newspaper than studying. Even as a college senior, majoring in political science, he felt he had to force himself to study. I saw a surprising side of Bill when I found, on his desk, an hour-by-hour work schedule and his "reading machine": a screen that moved down a page to get him through his reading assignments. Once the speed was set, it kept pushing him onward.

It wasn't all work. I joined Bill and his tight circle of friends to play Monopoly. I saw another side of Bill: I was shocked to find that he and the others stole money and grabbed extra spaces on the board. I now realize that their cheating was a way to make light of their own competitiveness, but at the time, I took their behavior more seriously than they did. I told Bill I didn't like cheaters, and this led to our first fight.

Even so, we were falling in love. We spent a lot of time walking, talking, and kissing in Glen Helen, the nature preserve next to the campus. We ate pizza at a tavern on Yellow Springs's two-block-long main street. We ordered porterhouse steaks at Com's, a popular joint in the Black section of town. And, occasionally, we splurged on a meal with friends at a fancy restaurant in Dayton called King Cole. We always went Dutch, in the Antioch tradition, and I had to save up from my meager earnings at the tea room to afford to go out with Bill.

Cooperative education was a central part of the liberal arts curriculum at Antioch; the co-op office maintained lists of employers all over the country and set students up with three-month-long paid jobs. As students advanced, the job placements would be lined up more closely to their majors. There were two co-op periods per year, which alternated with two academic terms. Bill and I began talking about coordinating our winter co-op work term, which would run from January to March 1955, as well as our summer co-op, from June to August.

For my upcoming co-op, I settled on a job at Gimbel's department store in Philadelphia. I wasn't yet qualified, via a specialty, for a more interesting job, and I reasoned that I would save money by living at home. Meanwhile, so we could be together, Bill took a half-time job as a research assistant to an anthropologist at Haverford College, while for the rest of his co-op, he worked at Gimbel's. His parents thought he was wasting his time. Like me, Bill would live with his family for the co-op term.

I hated living at home. It felt like a regression—and it was. Once again, I was cast into the oldest daughter/caretaker role. My father kept close watch over my virginity; he introduced a curfew, something we didn't have at Antioch. My mother, on the other hand, had gone radio silent. She barely spoke to me or

anyone else. (I didn't know it at the time, but she was already planning to divorce my father. Just a few months after I returned to college for my sophomore year, he moved out of the house.)

Once, when Bill came to my house to pick me up for a date, my father challenged him to a fistfight. He had only met Bill a few weeks earlier, yet there was Dad, putting up his dukes like a prizefighter and telling Bill to do the same. When Bill demurred, my father hit him lightly on the head. Without thinking, Bill hit my father back—and hard. What started as a taunt became a real fight, right there in the living room. The rest of us had to break them up. I was so angry with my father that I stopped talking to him. But he and Bill made up the next time they saw each other.

I finally met Bill's parents the following week. To say the meeting was more civilized than the scene at my house is not to say it was any more pleasant. When Bill first told his mother that he had met someone he was serious about, and her name was Zelda Finkelstein, she said, "Good." (Apparently, Bill had been dating non-Jewish girls at Antioch—and his mother wasn't happy about it.) That was before she realized I was the wrong kind of Jewish girl.

Edward Gamson, Bill's father, owned a small coat and suit factory, which he had taken over from his immigrant father, Chaim, many years before. Chaim wasn't good at business, and Ed dropped out of high school to help him. On the eve of World War I, Ed enlisted in the navy. When he got out of the navy, he went back to the factory and turned it into a success.

Like other upwardly mobile Jews, Ed and Blanche Gamson had succeeded in making it in America and throwing off the burdens of their parents in one generation. Blanche took this sophistication to another level: her parents had died by the time she was eighteen, and that freed her to move the sixty miles from Philadelphia to New York to enter show business. She went on the road with several shows and worked her way up to under-study for several stars. After marrying a non-Jewish man who was a press agent, she joined him at the pres-tigious Algonquin Round Table, where her husband held a peripheral seat. The

Round Table included composer Irving Berlin, playwright George S. Kaufman, writer and critic Dorothy Parker, and *New Yorker* editor Harold Ross.

Following a divorce, Blanche met Edward Gamson in the late 1920s. After he courted her for more than a year, she agreed to marry him. They spent a few more glamorous years in New York and then moved back to Philly and their respective families. Blanche gave birth to Bill's sister, Mary Edda, in 1931 and to Bill in 1934. Ed continued to run his coat and suit factory with a unionized workforce, who saved him from bankruptcy during the Depression by postponing payment of their wages. Ed made a lot of money during World War II and repaid the workers. When I met Bill, his family lived in a four-story town house on Rittenhouse Square.

While I considered her stylish, charming, and worldly, in Blanche's eyes, I was a step or two down the mobility ladder. I was from a markedly low-class section of the city, I was too Jewish, and my parents, unlike Bill's, were born in the old country. It did not matter to her that my father had gone to Penn, while Ed hadn't finished high school. His parents must have been suspicious of my intentions toward Bill because my family had no money. When Bill and I announced that we wanted to marry, Ed had a credit check done on my father, who ran his window-cleaning business off the books. I found the act alien and deeply insulting, but I never told my father about what Ed had done and don't think I said anything to Bill about it at the time. Knowing what I learned about my father decades later, I doubt that he even had a credit rating.

Looking back, I realize that my strong reactions to some of the behavior of Bill and his family reflected the fact that we had been raised in different social classes, with different class values: I was raised to be earnest, serious, and direct. So when Bill and his friends cheated at Monopoly, I found it morally wrong. He was raised to be strategic. When Bill's parents objected to his co-op job at Gimbel's, they saw it as a waste of his talents—while I saw it as just a job. They must have worried that I was a gold digger. And of course, they looked down on my father for earning his living from a small window-cleaning company.

Following Bill's Lead, Again

At the end of the co-op term, in June 1955, I returned to the camp where I had been a junior counselor when I was fifteen. Now a drama counselor, I directed a musical play about the Massachusetts island of Nantucket, which was a great success. Bill and I saw each other on weekends. By the time camp ended, our parents were driving us so crazy that we headed back to Yellow Springs a month before the start of the fall 1955 term. Bill was fighting with his mother, who I think hoped to break us up, and I was fighting with my father, who was trying to protect my virginity. Either way, we were strong as a couple and we had somewhere else to go. I returned to my job in the Antioch Tea Room, and Bill took a job in the college testing office, where he analyzed student data. It was a wonderful summer, full of play.

From that time on, I started fitting myself into Bill's plans. Because he was further along in his education, he was eligible for better jobs than I was, which meant that during our next co-op period, while Bill chose a job at a mini-mum-security prison in Cleveland as a rehabilitation counselor, I had to go to an employment agency, because the co-op office couldn't find a job for me. I hated the situation I was in, though at the time, I wouldn't have been able to name it or recognize that I was falling into a dangerously gendered dynamic. Instead, I simply felt I had lost my sense of direction and I fell into dark moods. I see this time now as the turning point at which Bill's and my paths started to diverge, with Bill taking the best opportunities available and me making do. Meanwhile, he often needed my street smarts to sort out difficult situations at his prison job.

I didn't feel better when I ultimately took a job as a mail clerk at Standard Oil of Ohio—the only job I could find through a local employment agency, which charged me a percentage of my wages. For eight hours a day, five days a week, I joined fifty girls and women sorting mail in a large office. We worked under the gaze of a female supervisor who sat in a glass enclosure a half story above us. I was given the additional task of delivering mail to various offices, and I welcomed the chance to move around. Just for the fun of it, I would push a grocery cartful of mail as fast as I could run down the hallways. I zipped through the corridors,

dressed in the pleated skirt, blouse, and brown-and-white spectator shoes I had worn in high school. Dreadful though this experience was, it taught me one very important lesson: never to take a nine-to-five job.

Bill and I rented rooms not far from each other. On weekends, we explored the city and came to love the Cleveland Museum of Art. We discovered Kelleys Island off the coast in Lake Erie, where there were wine festivals. Going to Kelleys reflected a deliberate decision to sleep together. We both lost our virginity that weekend.

In fall 1955, at the end of the co-op period, Bill and I went in separate directions—I went back to Yellow Springs, and Bill to grad school to study social psychology at the University of Michigan in Ann Arbor, a four-hour drive away. His parents were disappointed that he did not go to Harvard, but the social psychology program set him up for future success at the university when he took a job at Michigan a few years later. From that point on, the way was paved for him, because Everett Wilson, his sociology professor at Antioch, recommended Bill to Theodore Newcomb and Daniel Katz, key faculty in the social psychology program at Michigan.

We decided that we would try to see each other as often as we could. Bill would drive his bright new cream-and-green 1955 Chevy, a graduation present from his parents, down Route 68. I happily jumped back into my academic and social life, but this time I didn't date—I was "taken." I formed close relationships with the women in a shared house on campus, having serious talks about love, sex, and the lures and dangers of marriage. The lure was sex and intimacy. The danger was the loss of identity, just when we were struggling to figure out who we were and who we wanted to become. We couldn't help each other much, and we concluded that the decks were stacked against greater autonomy and freedom for us if we got married. We weren't sure that marriage, especially at our age, was the right thing. But we couldn't imagine any other option, since in 1955, we didn't have examples of women at Antioch or anywhere else who made other choices.

These conversations shook me. I knew that Bill was for me. (The only other contender was way above my pay grade: the dashing poet Mark Strand, then an

Antioch student and the crush of scores of girls, most of whom, like me, never went out with him.) Bill was solid, smart, funny, and sweet. We loved each other. On the other hand, I could already feel that Bill's life might overpower mine. I knew that I didn't need a man to define myself, that I only wanted to be with him and find my footing in the world alongside him. But I also understood—a little––that as a woman, my identity was being shaped by many forces outside of my choosing or control.

When my high school friend Chelly came to visit me in Yellow Springs, we talked about the dilemma of wanting to have time to develop our own selves, which didn't seem possible while married. I didn't have language yet for my specific fears about how I would remain Zelda, not only "wife" or, later, "mother." And this wasn't something I could connect about with Bill. As a "typical" boy at that time, he didn't worry much about who he was or how his identity might change throughout his life. He *did* worry about what he would study and what his work would be, Once he discovered the social sciences and attached himself to a mentor, he didn't look back. He would be a sociologist. And because I, like a typical woman of the time, would take on the running of our household, his roles as husband and father, as devoted as he was to them, would not get in his way.

Chelly and I did not resolve our dilemma during her visit. But she did wind up taking a less typical path: she did not marry until her thirties after a career as a market researcher.

Knocked Up

When I returned to Antioch for my second year, I combined two co-op job periods and moved to Ann Arbor for five months to join Bill. Joining a steady stream of students that Antioch sent to the Survey Research Center's coding department, I arrived in time for their annual survey of consumer finances. My job was to enter financial information onto a coding sheet and calculate taxes. Bored, I challenged myself to see how fast I could code and established myself as the fastest coder in the department—and the most inaccurate!

The man who headed the coding department rewarded me with a better job, as research assistant to an exhaustive study of adolescent development directed by the psychologists Elizabeth (Libby) Douvan and Joseph Adelson. I helped by running data on the IBM card sorter and summarizing the counts.

I shared an office with Libby, a brilliant scholar who was one of the few women on the faculty at the University of Michigan. In the office next door were two other brilliant women, the clinical psychologist Carol Kaye, who was a consultant to the adolescent study, and her research assistant, Kris Rosenthal, a recent graduate in philosophy from Cornell.

I hadn't been in Ann Arbor long when I discovered that I was pregnant. Bill and I used condoms—the main form of birth control then—and we couldn't figure out how it happened. I can't remember how I even found out I was pregnant, since getting a pregnancy test was difficult for a single woman. I must have missed several periods. I knew one thing—I was not at all ready for a child and wanted to get an abortion. Bill was stunned by our predicament. He knew he was not ready to have a kid, but he didn't know what to do.

Abortions were illegal, of course, and dangerous, but I was willing to risk it, and Bill was with me 100 percent. I turned to the only people I thought might help: my friends Libby, Carol, and Kris. I knew they would not pressure me to have the baby, and that they would help me if they could. "I think you would both make wonderful parents, but you're too young," Libby told me. Carol called friends and got me the names of two doctors, one in Pennsylvania and the other in Buffalo, who were purported to give safe abortions. I called my Antioch roommate, Mary Ann, to ask for a loan to pay for the abortion, and she immediately wired $350 to pay the doctor. It took a village.

Bill and I found ourselves in a shared nightmare. In the middle of winter, we took to the road and drove to some godforsaken town in the middle of Pennsylvania to track down the first doctor. When he said he could not help me, I was flattened by the news. Bill was also discouraged. But he followed my lead when I said we needed to press on to Buffalo. I was determined, though also scared; I didn't know what we would do if this second plan failed.

We arrived in Buffalo late at night, in a snowstorm, and located a basic motel typical of the time. Early the next morning, we found the doctor in circumstances much like those of the motel—his office felt seedy and dark, with a hint of danger. He told us to come back in the evening, when he would perform the abortion. We were both frightened but also relieved, and that night, after paying the doctor, I went into the room where the procedure was to take place. I felt some scraping in my insides, and it was soon over—not exactly a back-alley abortion but close to it. I cried when we got back to the crappy motel, and Bill held me. I was exhausted. What I hadn't expected was to feel guilt over what I pictured then and for the rest of my life as the tiny girl I had just aborted.

Bill and I did not talk about this episode until many years later. The experience made our relationship stronger. But it also left me feeling vulnerable in a way I had never felt before. Even after the births of our two children, my fear of getting pregnant remained. When birth control pills became widely available in the '60s, after Josh was born, I signed up immediately. A few years after that, I had a tubal ligation to prevent another pregnancy.

Shortly after the trip to Buffalo, we decided to get married. The abortion experience, though difficult, helped me realize that Bill was a steady, supportive partner with whom I could build a life. I wanted to have a marriage that was close and loving, without all the yelling my parents had done. I wanted stability and order and a husband who was cultured and intelligent, and I could see that I could get all this with Bill.

Still at my co-op in Ann Arbor, I trekked over to the admissions office and filed the paperwork to transfer to the University of Michigan. I was sad to be leaving Antioch. I even joked at the time that maybe I would stay in Yellow Springs, while Bill stayed in Ann Arbor, and we would meet each other halfway. But I wanted us to be together. So, for the third time in my college career, I began anew, albeit with many more courses under my belt.

On July 1, 1956, we were married. In those days, the bride's parents usually planned and paid for weddings, which were fancy and pretentious, though not as elaborate as many of today's weddings. I knew my parents couldn't afford it,

so Bill and I planned our own wedding. It was to be simple, no-fuss, and inexpensive. I designed our invitations in a bold, clean font printed on fine white card stock. We didn't need many, since we invited only our immediate families and a few close friends.

On the big day, about twenty-five people joined us at the distinguished John Bartram Hotel, across from the Academy of Music on Broad Street, in Philadelphia. It was not the most up-to-date place in Philadelphia, but it was a respected, old establishment. I had lined up a rabbi, Hirsh Cohen, from the nearby Reform temple Rodeph Shalom, who was reputed to conduct the fastest ceremony in town. I wore a lovely aqua tea-length dress with a crinoline that showed off my small waist. Bill wore his only suit.

Despite our efforts to control the event, my father and Bill's mother almost managed to torpedo our wedding. Blanche, who usually wore black dresses made of expensive crepe and silk, showed up in a black cotton Mexican peasant skirt and blouse, probably the cheapest outfit in her closet. My parents, recently divorced, sat at separate tables. Meanwhile, my father went around to our friends and Bill's family, saying it wasn't the kind of wedding he wanted for his daughter.

Maybe some part of me knew how things would go, because I neglected to line up a photographer. My half brother, Jerry, found one in the hotel lobby. The pictures of me and Bill standing glumly with my family were awful.

I found those photographs recently and they bear out my memories of the wedding. Good friends from Antioch and Philadelphia attended and they deflected our parents' worst behavior. The rabbi made the ceremony mercifully short. When everyone left, we went back to Bill's parents' house, hitched up a U-Haul, and packed up our stuff. As we drove off early the next morning, we were ecstatic. I was twenty, Bill was twenty-two, and we were finally free and on our own, together.

4

Finding My Mind

WHEN BILL AND I GOT MARRIED, IT GOES WITHOUT SAYING that I moved to Ann Arbor to join Bill. While I loved Bill, I felt terribly torn about leaving my beloved Antioch after only two years. I promised myself that I would stay in touch with the college in the future, and I kept this promise, serving on the board of Antioch when it became part of a university and working to revive the college when the university closed it down.

Life in Ann Arbor began badly. Adopting an instant dislike for the University of Michigan, I felt I had to uphold Antioch's values. And there was a lot to dislike! Fraternities and sororities dominated students' social life at Michigan, and that threw me back to my unhappy semester at Penn. In addition, Michigan is a Big Ten school, and I arrived in fall, on a home-game weekend. Bill loved sports (I had forgotten that he had been the sports editor of his high school newspaper) and made the mistake of taking me to a football game. I knew nothing about football and was not charmed by the pageantry—girls jumping around waving pom-poms, the screaming crowd. To top it off, a fight broke out between the fans of the opposing teams.

Bill had introduced me to a male world I didn't know and didn't like. He tried again by taking me to a hockey game—again, a sport I didn't know

anything about—where this time, a fight erupted on the ice between the teams following the game.

Sports and Greek life were not the center of our lives, however. I already had some friends from my time as an Antioch co-op student at the Survey Research Center, and I enjoyed meeting Bill's graduate student friends (all men).

Once I enrolled as a regular student at the University of Michigan, in fall 1956, it didn't take me long to understand that Ann Arbor, like Madison in Wisconsin and Berkeley in California, was a magnet for bright, creative young people from New York and other Eastern cities. Eastern (mostly Jewish) intensity and Midwestern (mostly non-Jewish) down-to-earthness encountered each other in bars and restaurants "downtown," where alcohol was sold; during the day, students' social lives were centered in the coffee shops around campus.

Bill and I rented an apartment not far from the campus that cost $75 a month. We lived on a fellowship Bill had been awarded by the university, supplemented by $350 a month from his parents and the earnings from my continuing part-time job with Libby Douvan at the Survey Research Center. My $400-a-year scholarship from the Philadelphia Board of Education paid for its third and final academic institution. Newly married, I suddenly became domestic and wanted to make my own home. Bill became my helpful assistant, going with me to the lumberyard for cinder blocks and unfinished boards for bookcases. A bedspread on a single bed and painted orange crates provided couch and tables. Our double mattress on its box spring sat on the bedroom floor, next to a mahogany dresser we hauled from Philadelphia after our wedding.

We were acquiring friends not only in the social psychology program and its related departments but also from across the university. Our little crowd included a physicist and a mathematician, a painter and a couple of musicians. At the very beginning of my first semester, I met Harriet Saperstein, who was a few months younger than me and newly married to a physics graduate student. She approached me by holding out her ring finger and saying, "I see you have a wedding band. So do I!" We have remained friends to this day.

I also discovered the pleasure of bringing people together. With Harriet's help, I hosted my first dinner party in honor of a visiting philosophy professor from France, Michel Dufrenne, whose course "Hegel, Phenomenology, and Existentialism" I was taking. The evening's menu is indelibly inscribed on my brain: chicken livers fried in onions and wine and seasoned with thyme, rice, some kind of vegetable, and brownies. We borrowed two card tables from the neighbors and covered them with a sheet. Voila! We had a wonderful time eating and talking. We could have been at Antioch!

Later that first year, in the cellar of the house on McKinley Street, we joined Antioch graduates who lived in the apartment above us to create a Halloween party on the theme of Seven Deadly Sins. We cleaned up the cellar but left the cobwebs hanging from the ceilings. I came as Envy, Bill as Gluttony. Then we put on music and the dancing began.

To my surprise, I discovered that I had not left the avant-garde behind when I left Yellow Springs. Another couple in the house on McKinley Street, a musician and an artist, created a "happening" outside an annual performance by the Philadelphia Orchestra. He and other musicians managed to find a hearse in which they installed him as a corpse wearing a black suit and white face paint. Puzzled passersby peered into the illuminated hearse. That the artists situated the hearse outside the orchestra hall was not an accident; it was a critique of the high arts of the time. The group that created the happening later became the nucleus of a larger avant-garde in Ann Arbor that organized exhibitions of contemporary art and an early experimental film festival.

Paddling in the Mainstream, Swimming Away

My classes at Michigan were pretty good, even the large, required lecture courses in English literature and psychology. I very much enjoyed an introductory astronomy course, which I took on the brink of space exploration. I continued as a philosophy major but had a hard time shifting away from the philosophical tradition of pragmatism I had studied at Antioch. The Michigan professors didn't respect pragmatism; rather, they adhered to analytic philosophy, the dominant approach

in philosophy at the time. I thought they were wasting time clarifying language when we all knew how slippery ordinary language really is. Their efforts, it seemed to me, were best left to linguists—and indeed, decades later, philosophers and linguists did often work together.

I also felt that the analytic philosophers made assumptions about human motivations that were best left to psychology. In the fall of 1957, the first semester of my senior year, I took an exciting course on the psychology of language with a young professor who was one of the founders of the new field of psycholinguistics. He taught us about Noam Chomsky's theory that the understanding of the structure of language is partially inborn—at the time, a revolutionary idea in linguistics and psychology. Chomsky's first book laying out this theory, *Syntactic Structures*, was published that year. I felt I was witnessing the development of a new understanding of how language works—and I was!

For a psychology course on motivation taught by a leader in the field, Jack Atkinson, I designed and carried out an experiment on aspiration for success. Instead of writing a single paper, I wrote a series of memos. The memos critiqued the methodology of experiments on the "level of aspiration," and I presented an alternative set of experimental designs. I then carried out an original experiment using shuffleboard games, the results of which I analyzed in detail, using simple measures of statistical significance.

In the meantime, I was also learning how to write philosophy, starting with a paper titled "When Philosophy Meets Psychology," in which I wrote:

> *I find myself in the unfortunate position of retaining loyalty (and sympathy) both for philosophy and psychology. In the current antipathy between the incensed parent, philosophy, and the wayward child, psychology, I find myself caught somewhere in the crossfire. My discussion, I am afraid, will be tinged with the inner confusion wrought by these conflicting loyalties.*

Less than a year after I wrote that paper, I'd learned how to take myself out of my writing in philosophy and to adopt some of the mathematical locutions of philosophical writing ("it is the case that," "it therefore follows that"). In other

words, I had become socialized into the intellectual norms of analytic philosophy—and lost what I now recognize as my natural writing voice.

Oddly—and even now I'm a bit mystified by it (pun intended)—I chose the topic of mysticism for my senior honors thesis. This was a strange choice because I hadn't had any mystical experiences, nor did I know much about Jewish mysticism, let alone Christian or Eastern mysticism. I had to tackle this topic pretty much on my own, since no one on the faculty had expertise in the subject. But I did what was becoming a lifelong habit for me and jumped before looking.

Attracted to the ideas of the French philosopher Henri Bergson about intuition and understandings that were not based on systematic analysis, I decided to open the thesis with him. Bergson was an important philosopher in the late nineteenth century through World War II, after which he pretty much faded in influence. I felt as if I had discovered him.

My training in analytic philosophy gave me the tools for analyzing the knowledge gained through non-rational thought. Though this was a possible contradiction, I plowed ahead:

> *What mysticism seems to offer is the possibility of a unique kind of experience. Intuition emphasizes an important aspect of experience which practical life and concepts embodied in language overlook . . . Since the kinds of experiences afforded by intuition are different from those we are able to express in words, it will be difficult to say just what this experience is. What intuition can do is to offer us a new way of viewing reality, and thus to permit different experiences of the world. Our ordinary ways of looking at the world blind us to the uniqueness of individuals. If intuition allows us to break these patterns, then it is certainly to be commended. Perhaps it is just this breaking through habitual modes of thought which makes mystical experiences so exhilarating.*

The thesis was returned to me crawling with comments from two readers: a graduate student, who used pencil, and a professor, who used a red pen. I had enjoyed the two courses I had taken with Paul Henle in the philosophy of science

and in logic, but Henle didn't have much good to say about my work. He found "inexcusable" my neglect of religious mysticism. Even his positive comments sound like backhanded compliments to me now. He wrote that I did a good job of "plowing through a long and complicated argument without ever getting lost … You do raise important points and present some good arguments."

Reading the thesis now, I feel even harder on myself than Henle was in 1957. I chose an ambitious topic (mysticism) that was far outside the realm of my prior coursework. The topic was too broad, and I did not really master the material. Applying the style of writing and the analytic skills I had learned from my training in analytic philosophy, I picked apart some of the logical questions concerning the subject of mysticism but never got to the heart of it. I coated the thesis with a veneer of mastery, but it didn't fool Paul Henle, the logician.

I've had the thought that maybe I chose mysticism as a challenge to Henle and his colleagues, to test whether I should continue on to a doctorate in philosophy. Or that maybe I'd already made up my mind to not stick with philosophy and was engaged in a bit of self-sabotage. The truth was, ever since I'd taken the earlier course in psycholinguistics, I'd wanted to study cognition and language through the lens of psychology.

But now that I consider this thesis in the broader context of my life, it strikes me that I may have chosen mysticism not simply because I was rash or rebellious but because the topic spoke to a belief that's continued to be important to me, personally and politically. I was drawn to Bergson's ideas because I wanted to make the case for intuitive thinking, which tended to be denigrated by rational thinkers. And so I was challenging, albeit amateurly, analytic philosophy in general—and possibly Bill, with whom I often argued about his being "too rational." My own tendency was toward the intuitive, and I identified with artists, mathematicians, and scientists—including Einstein—who made brilliant breakthroughs without being able to explain the steps that got them there.

Pivoting

When the time was right, I went to see the chair of graduate admissions about applying to the Michigan psychology department. My plan was to earn a master's degree in the time Bill had left to complete his dissertation. The problem, I learned, was that the psychology department did not offer a master's, just the PhD. I was disappointed. Yet I pivoted quickly—too quickly, I see now. I didn't know at the time how to think through my options or strategize around what I wanted. I didn't have the support system now offered, albeit meagerly, to many first-generation students in higher education. Instead, I entered the master's program in sociology at Michigan, in essence, making do, just as I did when I transferred from Antioch when Bill and I got married––and as I would do for the rest of my career.

I wasn't clear-minded enough at the time to realize that settling on sociology automatically put me in Bill's world. Bill had studied with many of the sociology faculty, and they already knew me as his wife, a denigrated role. I felt as if I had lost the opportunity to establish myself as an individual; for several years, I could not shake the feeling that I lived in his world rather than my own. I wanted my ideas and interests to not be mixed up with his. I knew, if my work came close to his, that he would overshadow me—as a man, as a successful sociologist, and as my husband. I desperately wanted to be independent of him, and to find an intellectual home that would allow me to shape a career.

Yet how did one do that—"shape a career"? It meant something very different for me than it did for Bill, in part because I was constantly changing schools, departments, jobs, and states to accommodate his career trajectory, which advanced in a more traditional, orderly fashion. But this wasn't all. I can also see now that the very things that set me apart and made me myself—my stubbornness, my independence—at times made it harder for me to make choices that might have led to a simpler, more identifiable path. Because I appeared more in control than I really was—to the outside world, and to Bill—and because I couldn't admit, even to myself, my need for advice or support, I forged ahead into a field that was not an ideal fit.

Throughout the rest of our lives, I would carry the label of "sociologist" when I didn't quite feel like one. Perhaps defensively, I looked down on the field. Sociologists, at least at Michigan, were not intellectuals; with the exception of Bill and a couple of his friends, the graduate students were not rewarded for writing well. Sociological writing was dense, unclear, and graceless. Sociology as a discipline had the feeling of an academic parvenu, one that kept having to prove itself compared to economics, history, and psychology. Practically every course I took in the master's program began with a section justifying sociology as a science. This insecurity drove the emphasis in the department at Michigan on statistics and quantitative data, which furthered its reputation as one of the leading sociology departments in the country. While I did not object to quantitative data and statistics and knew how to work with them, the courses I took for the master's degree helped me see that the best path was to combine quantitative with qualitative research.

When Bill accepted a job offer from Harvard, I once again needed to transfer. I looked into the Department of Social Relations; with its faculty drawn from clinical psychology, social anthropology, sociology, and social psychology, it promised an intellectually broader choice than the sociology department at Michigan. I was accepted into the department and I looked forward to Cambridge and Harvard. But I remember one afternoon, after the academic year had ended and we were in the midst of packing, when Bill's old Antioch friend, Marty Greenberg, came to visit. Suddenly, Bill had gone off with Marty to play tennis and had left me to continue packing. Fuming by the time they returned, I let Bill have it, at which point, without acknowledging that he had done anything wrong or apologizing, he then pitched in and helped drag some boxes to the hallway.

Perhaps for the first time, I wondered why it seemed that I did all the domestic work for both of us. I knew (and know) that Bill's work allowed us to live in great places and, later, to travel the world. I appreciated this, but it didn't change the imbalance at home. At least in the packing situation, the unfairness was blatant, unlike the countless invisible inequities and insults I faced when typecast as a faculty wife. In any case, it took the edge off my excitement about going to Harvard.

5

Upstream

MY FIRST MEMORY OF CAMBRIDGE IS ELSIE'S, A SANDWICH shop with a long counter that served two-inch-thick sandwiches. Bill and I sat at the counter with our sandwiches and tuned in to the people around us talking about politics—Jack Kennedy, from Brookline, was then running for president. Many seemed to be graduate students, who talked about their courses, professors and research. I wanted to talk like them.

We had rented an apartment on the third floor of a brown-and-yellow-shingled building, not far from Brattle Street and Memorial Drive. The rent was $85 a month plus utilities. The utilities could be expensive, especially the ancient hot water heater that you had to turn on if you wanted hot water. One Sunday afternoon, we took a ride into the country and forgot to turn off the hot water heater before leaving. When we got back, we had hot water in our toilet. So did our neighbors.

Our Antioch friends, Alan and Audrey Gartner, had moved to Cambridge when Alan was accepted by the history department for graduate work. They lived a few blocks away with their adorable baby; it felt good to have them nearby. When it turned out that Bill would not be receiving his first paycheck from Harvard for a month, Alan loaned us some money. Our furniture likewise took a month to arrive, so he and Audrey also loaned us a mattress, which we set on the floor.

Back to School

My first introduction to the culture of Harvard came when I interviewed for a fellowship at the Social Science Research Council. My interviewer and I had a cordial chat about my interests and experience as a graduate student at Michigan. At the end, he asked me a question that took me by surprise: "Why," he asked, pointing to my wedding ring, "should we give you a fellowship when you will have a baby and drop out?" In a voice lit with fury, I told him I would have a baby and I would *not* drop out. I suppose that was the right answer, because I got the fellowship.

Bill, in the meantime, was finding his way at Harvard. His colleagues in the social science unit at the School of Public Health were a close-knit and friendly group. They welcomed Bill to their world with open arms and smoothed his way through the university. They also welcomed me. A support group of wives had grown up around the program; they put on dinner parties and other social events. As soon as I met them, I worried that they wanted me to join them in these tasks. This made me uncomfortable. I had not done this at Michigan; I had my own responsibilities as a graduate student.

The Department of Social Relations was a stimulating place. I could take courses in anthropology, clinical psychology, and social psychology in addition to my primary affiliation, sociology. I had access to any course I wished to take, as long as I met the requirements in sociology and passed the preliminary exams.

I took a course early Tuesday and Thursday mornings with Barrington Moore on change and revolution, which he ran in the form of a Socratic dialogue. This annoyed me because, first of all, it wasn't a dialogue; he asked the questions, and the class was expected to come up with the answers he had in mind. When he got around to me one day and asked me to define charismatic authority, I looked at him in annoyance and said, "Oh, it's that certain something"—not a bad answer, as I think about it now, but not what he had in mind.

A slight smile flickered on his face; maybe he didn't mind my sass. I came to admire him—a patrician Marxist with great self-restraint. Even though I was critical of his teaching methods, I loved the course because it examined social

structure as a force capable of resisting change and generating it. Furthermore, social change almost always involved increased conflict. My respect for sociology increased tenfold when I read Karl Marx and Max Weber for the first time.

Moore became my ideal of an engaged intellectual, who helped create the field of historical sociology. He was the very opposite of Talcott Parsons, the reigning king of sociology, whose thinking reflected the times, when harmony was valued and conflict written off. An abstract and abstruse writer, trained in Germany, Parsons taught required courses in the department. Those courses drove me crazy—I couldn't make heads or tails of what he said in class and thought I was the only one who felt that way. When I asked the other students to explain what he meant, they could rarely tell me. "But you were nodding," I said, "so I thought you understood."

"Oh," they would say, "I just wanted to show Professor Parsons that I agreed with him." I turned away from these guys in disgust.

As a woman, I was one of a few tiny drops floating in a sea of men. In the Department of Social Relations, there were only two women on the faculty, both anthropologists. Florence Kluckhohn was married to a famous anthropologist, Clyde Kluckhohn. I believe that her title in the Department of Social Relations was "lecturer," a nontenured position (tenure being the gold standard of academic legitimacy). Another anthropologist, Cora DuBois, not married, probably held tenure.

Nevertheless, at least at Harvard, I could finally see women as faculty members, unlike my experiences at Penn, Antioch, and Michigan. In my eyes, that made them special, and I watched them closely—Kluckhohn with her large pieces of Navajo jewelry, and DuBois with her cigarette holder.

I became friendly with two women, Carol Pierson and Dorothy Zinberg, in my entering PhD class. The male graduate students were not as interesting to me as the women, with a few exceptions. In my search for people I could talk to about language, I met an advanced anthropology grad student, Volney, who was interested in the new field of sociolinguistics. Volney was a Reed College graduate. At the time, Reed and Antioch were alike in their academic intensity (if not in

their educational philosophies). Volney and I would spend hours in the Bickford cafeteria and an occasional bar in Harvard Square, generating questions about Chomsky's theory; about the Whorfian hypothesis, which posited a strong effect of language on thought; and about psychological studies of language acquisition.

The climate at Harvard, even in the social sciences, did not support cooperation. I wanted to gather a study group, modeled on those we'd had for graduate courses at Michigan, to divide up the note taking. This saved time and produced excellent notes. The group would then discuss the readings, often at a very high level. I invited Dorothy, Carol, and a former Michigan undergraduate I knew from Ann Arbor to create a study group. A few male students from our classes quietly approached me and asked to join. "But it doesn't work when there are more than four or five participants," I told someone I turned away. "Why don't you start your own?" As far as I know, this did not happen.

In the end, my first year was a success. As the academic year 1959–60 was ending, I was astounded to find that Frederick Mosteller, my statistics professor and a prominent member of the statistics faculty, had nominated me for the annual statistics prize. I was taken aback, since I wasn't a star math student; I did, however, take to statistics while most students complained about it. In particular, I loved probability theory because it fit with my view of the world, which was that almost nothing was ever just one way. I loved ambiguity and, strangely, that love may have won me the prize.

Knocked Out

My first year at Harvard turned out to be my last year as a student unencumbered by the responsibility for childcare. By the time I completed the academic year, I was five months pregnant. I knew it was right this time. Bill and I were older, we were surrounded by friends having babies, and we knew we could take good care of our own.

For medical information, I turned to Mary Field Belenky, a friend from Antioch who was due to deliver a couple of months before me. She recommended an obstetrician she was seeing with hospital privileges at Boston Lying-In Hospital.

I went to see him, and he seemed like he would be alright, though I wasn't actually doing any comparison shopping. He wore a bow tie, spoke elegant English, and had me totally intimidated. I didn't know much about pregnancy and delivery and didn't try to find out about them on my own.

I was in good health, though I did smoke occasionally and drank some wine and an occasional scotch. During the pregnancy, I tried to eat a lot of salads and other produce and a minimum of sweets and meat. I did this on my own—there was no diet counseling or any other counseling, for that matter, at the mecca of medicine. I was due on August 26. When my doctor advised that I be induced on August 15, I agreed; he was the doctor. Only later did I realize that he probably picked the date to fit his vacation schedule, August being the time when many doctors in Boston took vacations. I was told that it was common to induce the birth of large babies whose mothers might have trouble delivering them. But this wasn't the case with my baby, who weighed just over seven pounds at this point. On the other hand, it was nice to know when Baby Jennifer or Baby Christopher would be born.

On August 14, the night before the delivery was scheduled, Bill and I went with friends to a famous delicatessen, Jack and Marion's, on Harvard Street in Coolidge Corner, Brookline (close to where I live, sixty years later), and I had a delicious chopped liver sandwich on rye with a pickle.

What happened next was so horrific that I still shake with anger when I remember it. Bill and I went to the hospital early the next morning. They gave me the drug that would speed up labor—Pitocin, I think—and that is all I remember of the birth. I was knocked out. When I came to, confused and disoriented, I had a baby in my arms. She was beautiful and perfectly formed at seven pounds, four ounces. Bill was standing by, and there was a bassinet in the corner of the room. I later learned that I was in Richardson House, an exclusive part of Boston Lying-In Hospital. The bassinet was because I had signed on to a new program for mothers who wanted to take care of their babies right away, an unusual idea at the time. Bill, the father, was excluded from the delivery room, but while I was still unconscious, he was allowed to hold the baby and change her diaper.

As I took in my surroundings, I noticed that I had red marks on my arms. When I asked the nurses about the marks, they avoided answering. I suspected that something had happened to me in the delivery room, and that the red marks were from being tied down.

The experience was so frightening, I put it out of my mind for fifty years, until I saw an episode of the TV series *Mad Men*, in which the main character's wife is put into "twilight sleep" while in labor in the late '50's. On the show, although we hear her screams and curses from the waiting room where her husband is waiting, the woman, like me, remembers nothing afterward. This was when I learned that I had presumably been given an injection of scopolamine, which causes patients to become semiconscious and not remember their labor pains and the birth of their babies. Hence, "twilight sleep." Paradoxically, this drug had been taken up by the early Suffragists, who'd advocated for hospitals to put aside special maternity spaces for the new approach to labor and delivery.

By the time I watched *Mad Men* and put all the pieces together, I was close to eighty years old. And only recently did I learn that an exposé in *Ladies' Home Journal* had uncovered a pattern of traumatic births under twilight sleep—in 1958, two years before I went into labor! What was my fancy doctor doing using a discredited delivery method?

Even though at the time I was kept in the dark about what really happened to me, the experience put me more on guard about the medical system. I began to see that as a woman, my body—via sex, pregnancy, and childbirth—was subject to the force of a society in which women were useful for purposes that were not our own. Later, my experience of belonging to a women's group and reading feminist texts helped me see this even more clearly. My awareness started with Jenny's birth.

Raising Jenny

At this time, Bill was in the midst of research that would make his name as a political sociologist. After Jenny was born, he took a couple of weeks off from traveling to small towns in New England to study conflicts over water fluoridation, but for the most part, I was on my own with the baby, who was sweet and

agreeable but still a baby. My last experience with a baby was at age twelve, when I helped my mother with my youngest brother, so I needed to learn afresh how to take care of ours.

Jenny was born in August 1960, more than a month before the start of fall classes, so I planned to continue studying without taking a break. If I took off the fall term, I feared that I would never come back—not an unrealistic fear, since many women never did return after taking a "break" from schooling. The question was who would stay with the baby while I was in class and studying for my doctoral exams later in the year. I interviewed several women and hired a lovely youngish African American woman named Barbara who took care of Jenny twelve hours a week—exactly my time in class plus travel from Foster Street to Harvard Yard and back.

Breast-feeding was not difficult—and heaven forfend that it should be, since there weren't any lactation consultants to help in those days—but it seemed strange until I settled into it. I decided to convert our dining room into a nursery, covering our new teak dining table from Design Research with a double-thick crib pad and a waterproof cover to make a changing table. We set up a bassinet in our room, and later a crib. Of course, the crib was immediately outfitted with a mobile, thought to be good for babies' brain development.

The rest of the time I spent trying to read and study for the final doctoral exams at the end of the year while taking care of Jenny. I remember one horrible afternoon when I was trying to read the philosopher Alfred North Whitehead for one of my courses. Jenny was in my arms, bawling. After a while, I joined her, tears streaming down both our faces. I had been alone for several days while Bill traveled to a town in Maine for his research. I knew how important his research was but still felt abandoned at home while he was gone; it was like Bill going off to play tennis with Marty and leaving me to do the packing, only much harder. It's easy to see why most of the women I knew who married when they were still undergrads wound up dropping out of school when they had kids. Even as a grad student, I felt my options shrinking down.

It wasn't all diapers and tears. I made it a point to take Jenny in her stroller for walks along the Charles River and into Harvard Square. When she was a bit older, I commandeered our car for outings to my favorite street in Boston, Newbury Street. Jenny turned heads.

Because we had to stay home with Jenny, our apartment became a center for friends. My study group met at our apartment. Two Antioch friends, Dick Snyder and Marty Greenberg, joined Bill to create a baseball bidding game which was picked up later and developed into what is known now as fantasy baseball, a lucrative business that subsequently expanded to other sports. Dick and Marty disappeared from our lives, but Bill became known as the "godfather" of this industry—though he never earned a penny from it.

During the 1960 presidential debates, friends joined Bill and me, with Jenny burping happily to Jack Kennedy and farting to Nixon. Bill's sister Mary lived in Cambridge at the time and visited frequently. When her parents joined her to see their first grandchild, they were delighted.

Reunited with Bill's parents, Blanche and Ed, that summer on Cape Cod, I realized that producing a lovely grandchild had done nothing to soften Blanche's view of me. I am sure she disapproved of my continuing to study. When Bill helped with the dishes or with the baby, she complained that I was taking advantage of him. In her view, my job was to serve Bill and the baby.

Wherever I went, the people I met expected, because I was a wife and mother, that my ideas and ambitions were unimportant. But I knew I was more than that. I knew I was a gifted thinker and writer and had been recognized all my life for these talents.

About a month after Jenny was born, I went to retrieve a graded paper from campus, pushing Jenny's carriage from our apartment to Emerson Hall. The senior administrator for the department was the forbidding wife of Professor Parsons, who controlled access to him and other senior faculty. When I walked in with Jenny in my arms, Mrs. Parsons smiled at the baby. She took me to her husband's office, where I found myself in a very large space filled with Oriental carpets, dark furniture, and floor-to-ceiling bookshelves.

Parsons was a diminutive man, and at five feet, five inches I was a few inches taller than he was. He raised his head a bit to talk to me and smiled kindly (though his teeth were yellowed and his breath a bit sour, probably because of his smoking habit). "How was your summer?" he asked, as he handed me my paper. "I had a baby," I replied, "and here she is." He recoiled in embarrassment. To this day, I wonder what embarrassed him—my bringing an infant to his inner sanctum, what I had done to produce the baby, or the simple fact that I had a body.

Despite such interactions, I promised myself that I would remain a student, no matter what. I would not drop out. I persevered, and I must have looked from the outside like I had things under control, but inside I felt frantic. I never had enough time, and the time I did have wasn't mine to allocate as I wished. Not surprisingly, this was when I started having terrible headaches, which would afflict me off and on for the rest of my life.

The following year, when it came time for my oral doctoral examination, I gave it my all, staying up late, plotting not only what I would say but what I would wear. In the end, I passed but felt I hadn't performed as well as I could have; my attention was divided between my academic pursuits and my duties as a mother. And when it came to preparing for the written exams, I felt that I couldn't study as I knew I should. When I sat for the written portion of the exam, I genuinely worried that I might not pass. I did pass—but without the special recognition that I often received. *Just passed*, I thought to myself. *Not good enough.*

By that time, I had stopped shooting the breeze with Volney and other grad students. I didn't want to leave the baby more than those twelve hours a week when Barbara was covering for me. All of my friends with babies stayed home full time, so I felt I needed to live up to that standard and somehow do it all. I never thought to cut myself some slack as a twenty-four-year-old graduate student and mother; I didn't think of myself as different from the other graduate students. But I was! Most students did not have children and, if they were men and married, they had wives to handle childcare and the household.

I continued to take courses while working on a dissertation proposal. Then, in March 1962, I found out I was pregnant again. Bill and I didn't talk

about the implications of the pregnancy for progressing with my dissertation; sometime around then, he was approached about a tenured professorship in the sociology department at the University of Michigan, which he accepted gladly. He was becoming well-known in his field. At this point, I did what I usually did: fit myself into a situation shaped by Bill's career and coped. I assumed, as I always did, that I would be able to handle what the situation required, and I took pride, perhaps at my own expense, in not seeming to need help.

A Dissertation Emerges

First, I realized that I would have to find a dissertation topic that I could pursue from Ann Arbor. I was playing around with a number of ideas that drew on my background in philosophy and the study of language, but none coalesced into a research proposal. I was just about over morning sickness and thinking about what I should do when I got a suggestion from Carol Kaye, the psychologist in the group of women I had worked with at the Survey Research Center. She was carrying out a study of the impact on students of Monteith College, a new college at Wayne State University in Detroit.

She offered me the data from her research for my dissertation. I jumped at the chance but realized that I wasn't interested in her main question. What I really found intriguing was the college's experimental model, which offered non-elite students an elite liberal arts education patterned on the University of Chicago's Great Books curriculum. At the time, that was an unusual thing to do; a few years later, it became more common to bring a first-class education to non-elite students.

I decided to turn the question of impact around. "What," I asked, "was the impact of the non-elite students on the college's mission and culture?" Using organizational concepts and a bit of editorial sleight of hand, I constructed a dissertation proposal that was accepted by the time we left for Ann Arbor. I had the significant support of David Riesman, who was doing a comparative study of educational innovation at Monteith and Oakland University with the

sociologist Joseph Gusfield. I introduced myself to Riesman, and soon he became my academic sponsor.

A German Jew from Philadelphia, Riesman was more of a Brahmin than a Jew. His wife, Evelyn (Evie) Thompson, a graduate of Bryn Mawr and a writer, was a wisp of a woman, beautiful and delicate. She traveled with David on his trips to colleges and universities around the country and sometimes abroad. They each kept their own detailed field notes on what they saw and discussed them every evening.

David Riesman encouraged and inspired me for years to come. Even though he expected his own wife to support his work, he completely believed in me at a time when I wasn't sure I would complete my doctorate. His automatic support gave me the strength to go on despite the obstacles I encountered. I admired him because he was an intellectual—much more than a regular academic—and a bit of a renegade. It was unusual for him to take on a graduate student. His advanced degree was in law, not in sociology, and he insisted on being called *Mr.* Riesman. By the time I met him, he had published his most important work, *The Lonely Crowd* (1950), a broad-ranging analysis of American culture which argued that American character was shaped less by adherence to a set of values (inner-directed) than by following the standards of other people (other-directed). Many professional sociologists were critical of this best-selling book. But when I read it as an undergraduate, I loved it.

While Mr. Riesman would not be an official member of my dissertation committee, he attended my dissertation proposal meeting, conducted by the sociologist Alex Inkeles, who had agreed to be my chair. Inkeles had been my professor in a course called "Personality and Social Structure," and I learned much from him about the study of organizations.

In August 1962, I once again packed our belongings for Ann Arbor, where Bill would start his professorship in the Michigan sociology department. I was twenty-six, Bill twenty-eight. We were adults building careers in academia and would soon have a second child, but we still felt like grad students. Our new lives in Ann Arbor would change that.

6

Feet First into Adulthood

AFTER THREE COMPLICATED YEARS IN CAMBRIDGE, WE returned to Ann Arbor in August 1962. This time we came with more baggage—a house, a toddler, and a baby on the way. Bill and his father had flown to Michigan that summer to look at real estate. "Look in the young faculty section of Ann Arbor," I told them. "I want a working fireplace and an enclosed backyard for the kids."

Jenny had her own opinion. "I want a *pink* house," she chirped.

Bill and his father chose well. They found us a stucco house painted pale pink in the Burns Park neighborhood, where several of our friends already lived. The price was low and so was the interest rate on the mortgage we took out. Enormous old oak trees lined both sides of the broad street; on warm evenings, we could hear bats flapping among the trees. A large treehouse built into the branches of an oak stood in an enclosed backyard behind the house.

We lived a ten-minute bike ride away from campus, about twenty minutes on foot. Behind our house stood the Burns Park Elementary School, a playground, and playing fields. In the winter, the town flooded the softball field to create a skating rink with a warming house located next to it. The scene was straight out of Norman Rockwell paintings. In the winters to come, Bill and I strapped on the kids' new double-runner skates and watched them hobble over to the ice.

6

Then I strapped on my skates and joined them while Bill trained our Super 8 movie camera first on Jenny and then on Josh, taking three or four running steps, falling down, and getting up.

During those years, we formed close bonds with several communities in Ann Arbor. There were a few families who lived near Burns Park who, like us, were involved in the anti-war and civil rights movements, and whose kids went to school together; some people called us the Burns Park Mafia. We had historian friends who hosted Friday-night gatherings where we watched classic American films on a reel-to-reel and smoked pot. With two friends in the neighborhood, I joined an early women's group that put on an amazing women's film festival. We had other friends who would take care of our kids, and vice versa, so the adults could travel. And I threw great dance parties. By then, when he no longer had to lead, Bill had come to enjoy dancing. He was more expressive in his movements and in his face. He said he loved how joyous dancing made me—he could see how transported I became when I danced.

I realize now that these communities came together at a time when life was less professionalized and stressful than it would become only a few years later. I'm grateful I had a chance to experience the kind of loose boundaries we created between home and work and work and play—the interweaving of families passing through the seasons in Burns Park.

The Walls Came Tumbling Down

But before all that, and even in the midst of it, I struggled. After we got to Ann Arbor, the baby, due November 1, took a long time to arrive. I went about my business while carting around a belly that weighed more than eight pounds. "I feel like I'll be pregnant forever," I told friends, "so I might as well just stay active." On November 15, I threw a party for my friend Kris Rosenthal, who was visiting from Cambridge. Just as people were beginning to arrive, I was surprised as water trickled down my leg. My friend Joanna, who had helped me set up for the gathering, knew what was happening. She hustled me out the door with Bill, promising to tend to our guests. From the hospital, Bill would phone in my measurements,

so to speak, and as the party was winding down a little past midnight, Josh was born. He was fully awake and looking around, another perfectly formed infant.

When I got home from the hospital, I found my eyes tearing up a lot. Friends came by, and their company cheered me, but I would sink again as soon as they left. Was it postpartum depression? Looking back now, I realize that I felt trapped—overwhelmed by responsibilities, my spirit quashed by hundreds of soul-deadening details. At the time, I couldn't say these things out loud because I couldn't even admit them to myself. I was supposed to be happy to make a family and settle into a new home. But my worries about how I would do everything for the babies, for the house, for Bill, and for myself overshadowed those pleasures. Speaking to Libby, who was sympathetic to my plight, I said, "I don't even have a place to do my own work."

Why shouldn't I have felt this way? I had only just settled into a new life. I had a toddler and a newborn and was a first-time homeowner. Bill felt overwhelmed himself as he was starting a new job, helping with Jenny, being responsible for a mortgage payment, and new expenses. He tried to help me, but it was clear that I was in charge and also had to execute most tasks; I was the manager and the worker. It was a blur of nonstop activity: trying to get Jenny settled happily with walks to the park and play dates, keeping my hand in my dissertation work, and going to sociology department dinner parties.

Still, I didn't let the arrival of our second child stop my academic work or domestic tasks. I decided to put off my fieldwork until Jenny was older and the baby in good shape. Instead, I focused on tasks that could be completed at home, prioritizing house tasks like fixing up a playroom and redesigning the living room. Once the house was painted and the basement rooms carpeted, I felt the house was my own. But where was my study? Until Josh was born, I worked in a room between the kitchen and dining room. It made sense to be close to Jenny and the kitchen. But it didn't actually make sense if I was to get any work done. Unable to find another work space, I eventually set up a table for myself in Bill's study. The basement room took me out of the household traffic and settled my mind down to my work.

In the winter of 1963, when I turned to my dissertation, it was a relief just to think again. But how would I make time for it? I breast-fed Josh, as I did Jenny, for about four months, weaned him to the bottle, and then deployed my coping powers to figure out how I could continue working. I realized that I could be the manager without carrying out all of the household and childcare chores myself. After talking it over with Bill, I decided I would look for a nanny who could also help with the housekeeping chores. The affordable solution was to hire a live-in housekeeper. I placed an ad in the local newspaper and heard from one woman who appeared perfect. In her forties, Gloria was recently divorced and new to Ann Arbor. Her nine-year-old daughter, Elizabeth, would also move in with us. Gloria seemed ideal for us—domestic, intelligent, warm.

Although she was great on paper, Gloria and I were a terrible match. We were both unhappy and couldn't find a way to reach one another. She obviously missed running her own household but didn't know how to adapt herself to mine—and I made it clear that I was the one in charge. She wore aprons all the time and bored me with her advice about how our household should be run. We disagreed about how she should relate to the kids; she was fine with Josh but wasn't much fun for Jenny. In the end, she got on my nerves, and I asked her to leave after six months. At the time I felt ashamed that I couldn't make our arrangement work. Now, I recognize that I needed to act, and act quickly.

The timing was right, because a few months later, I found a better solution to my predicament: a twenty-year-old au pair from Norway named Randi. I had not seen the term "au pair" written, and when I heard it, I thought it meant "au père," as in "to the father"—not too far from the truth. When she finally arrived at our doorstep, a Scandinavian Mary Poppins, I liked her immediately. She was shy at first and had a strong, broad face, short blond hair, a tiny waist, and wide thighs. She had a charming accent in English and a wonderful way with the children.

We were all lucky to have found Randi, and I treated her like a treasure. She had all the kinds of womanly skills I lacked. She could design and sew clothes, making matching dresses for Jenny and me, and knit Norwegian sweaters, which she made for Jenny, Josh, and Bill. She sat happily on the living room carpet for

hours with the kids, playing with dolls and stuffed animals, making pictures, and teaching them expressions in Norwegian like "Takk for Maten" (thanks for the food). Randi was also a musician and taught Jenny and Josh songs in Norwegian. We did not exactly become friends, but we worked well together.

The Motor City Experiment

Once Randi was settled in, I began weekly trips into Detroit for my fieldwork at Monteith College. Only forty miles away, Detroit was the big city to the college town of Ann Arbor. As a city girl, I clicked into Detroit immediately. I loved driving into the city for my fieldwork.

Monteith College was an ambitious experiment in higher education, one of the first colleges to take seriously the educators' claims that studying the liberal arts was not just for elite students but for everybody—even commuter students whose parents hadn't gone to college, who didn't have much money, and who viewed higher education as preparation for jobs. Experiments in higher education like Monteith have popped up periodically throughout US history, but the school was unique because it offered an elite education in a "streetcar college," an old-fashioned name for a commuter college.

In 1959, Monteith College opened its doors to students in a building tucked into a corner of the Wayne State University campus. Emphatically billed as *not* an honors college, the curriculum was nonetheless rigorous. Over four years, students were required to complete general education requirements in three interdisciplinary departments: humanities (literature, music, painting, and philosophy), social sciences (psychology, sociology, anthropology, economics, and history), and natural sciences (biology, mathematics, chemistry, and philosophy). The students who made up the first few entering classes were selected to resemble the Wayne student body as a whole. Over time, this system broke down, and the students became more self-selected according to social class, major, and background; this self-selection produced an overrepresentation of middle-class, artistic, and intellectually curious students.

The faculty was the key to the success of the college. A respected faculty member from the Wayne English Department who had spoken for the creation of Monteith was appointed as dean, and he and a search committee immediately set about recruiting faculty from Wayne and from other colleges and universities. He knew he wanted to find people who were respected in their disciplines and interested in teaching first-generation college students. He perhaps could not predict that interdisciplinary teaching would turn out to require more collaboration than was typical—certainly more meetings—since faculty members were expected to teach together, visit each other's classes, and constantly monitor their students.

I had hit on a topic for my dissertation that resonated with my own life. Although I was not technically a first-generation college student, since my father had gone to university for two years, I felt like I was. I believed in what Monteith College wanted to accomplish and I wanted to understand whether and how it could work. I knew it would be difficult and, as a student of organizations, I realized that the larger university would inevitably create obstacles for the fledgling experiment in its midst. I expected that not all of its students would take to the liberal arts and would want to prepare themselves for jobs. I wanted to know how the faculty and administrators at Monteith coped with these forces.

I arrived on the scene in 1963 at a good time to see the college operating at full capacity, with four graduating classes filling classrooms and faculty offices. With Randi back home with the kids, I could really take my time interviewing faculty and students, sitting in at meetings and visiting classrooms, reviewing curriculum materials and data about the students. My primary research question, based on my thesis proposal, asked whether and how Monteith changed in response to its students. When I started my fieldwork, I saw almost immediately that this question needed to be revised. As I put it in my final dissertation:

My thinking . . . went through several stages . . . but it was only when I entered the field and was confronted by a fundamental and unanticipated characteristic of the College that my ideas took final shape. The fact that I was forced to face was the existence of important internal differentiation within the College. There were two departments at the

College which, from the beginning, had different perspectives, values, and educational philosophies. Different norms developed in the two departments about what was desirable behavior for faculty and students. These . . . had consequences for faculty responses to the students.

Immersive research suited me well, and soon I became a fixture at Monteith, taking notes and taping interviews on my trusty tape recorder. Between trips to Monteith, I recorded and organized my field notes and began writing notes to myself about what I was learning.

At one point, I turned to Bill, who was a terrific clarifier, for help in pushing my way through the piles of data and multiple ideas that were buzzing around my brain. With his help, I came to see that the impact of students on the college varied according to who the students were and which aspects of the college were being impacted. The students who took to the college—who were most involved in the social and intellectual life of Monteith and who received the most rewards from the faculty—put direct pressure on the college to become more demanding and give them more opportunities for independent work. They formed a core group within the student body who were closely connected to the social science department. Students who were less involved in the college, particularly those in preprofessional programs, were less likely to try to influence the college. Many professors at Monteith struggled valiantly to reach these students, and some did. They embodied the founding principle of Monteith to bring the liberal arts to preprofessional students.

This founding principle weakened over the years, partly because the students themselves did not adopt the ideals and demands of Monteith. Perhaps this outcome could have been prevented had the faculty been united, but the faculty, to say the least, did not work harmoniously. Conflict between natural sciences and social sciences faculty was continuous. The social sciences faculty was intense, articulate, ideological, vivid, and cohesive. The natural sciences faculty were less intense, less articulate, not ideological, and not cohesive (at least initially). As one of my informants from the natural sciences put it:

*We have two entirely different conceptions of the relations between
students and faculty, the nature of general education and how a college
should be organized. We are really not one college. We're at least two
and maybe three. Every place where we've attempted to come together,
we've failed . . . There is a genuine difference in values. We are about
as different as night and day, just through and through, like cats and
dogs . . . We frustrate each other and confuse the students. This may
very well doom the college.*

Indeed, Monteith College was shuttered in 1978, only twenty years after the
planning committee began its work. In the minds of some Detroiters, Monteith
lives on as having been a base for radical politics and experiments in the arts. The
choice of Monteith for my dissertation shaped the questions I would continue to
ask of higher education. What was it doing for first generation college students?
How did innovation work organizationally? What would ensure that innovations
lasted? In the background of my research, I was unconsciously absorbing how
small colleges feel—how tortuously curricula change, how faculty work (and
fight), and how crucial it is to understand students' lives holistically. Monteith
provided me with a storehouse of anecdotes and ideas that I would draw on
throughout my career.

Monteith reinforced my fascination with the organizational forms of
experiments in higher education. I have no doubt that my two years at Antioch
inspired my work, whether I was aware of it or not at the time. Like Monteith,
other innovative colleges founded in the twentieth century—notably, Black
Mountain College in Asheville, North Carolina—did not last long. Antioch,
founded in the nineteenth century, had a more solid foundation.

The book I eventually wrote with David Riesman and Joseph Gusfield,
Academic Values and Mass Education (1970), was an ethnography of Monteith
and Michigan State University's Oakland campus, both of which aimed to create
the opportunity for non-elite students to receive an elite education.

Faculty Wife

My research was proving satisfying and important, yet I still couldn't shake the labels of "wife" and "mother" that seemed to follow me wherever I went. The conflict between being a graduate student and being a faculty wife had been rather negligible in Cambridge. But when we moved back to Ann Arbor in 1962, the conflict deepened. I was now a mother with two toddlers but still a grad student, albeit one who had left Harvard with a dissertation yet to be written.

Soon after we moved into our pink house, I received an invitation to a kaffeeklatsch gathering of neighborhood women. The kaffeeklatsch was a get-together that, happily, wasn't built around husbands; these women were anchored firmly in their homes. This was a world I hadn't known a few years earlier as an undergraduate at Michigan, a grown-up world with houses, furnishings, housewares, and most especially children. Like the other women, I put a lot of energy into running my household. I felt confident that I could create a better, less chaotic life for my family than my mother had, and I was right. I thought carefully about where we lived and what kinds of furnishings and dishes and paintings I bought. I looked at other people's homes for ideas. And I ran a fairly tight ship in terms of keeping the household orderly. I also cooked, of course, though I wasn't particularly good at it and eventually wound up creating a system to enlist Bill and the kids' help.

I loved my home, my children, and my husband—but I wanted more. Yet almost immediately after we arrived in Ann Arbor, I found myself drawn into a roundelay of university dinner parties. The first was a formal one for new faculty at the home of the sociology department chair, Guy Swanson, with whom I had taken a course when I was an undergraduate. His wife did the cooking and serving, silently moving among the guests and then disappearing. As I soon came to appreciate, dinner parties in Ann Arbor took a wife's whole day, if not two days, to prepare. In the 1960s, standards for such gatherings were very high—gourmet food, good wine, beautiful table. These standards were hard to meet, because Ann Arbor at that time did not have good food stores, which put an extra burden on the wives who prepared the dinners. Sometimes they would have to order

specialty items like seafood in advance, or travel to Detroit for ingredients. By the time dinner was ready, the cook—now doing the job of server—was exhausted.

The unpaid work of faculty wives was rarely recognized and frequently devalued. At a few dinners, I witnessed husbands ridiculing their wives. One department chair in particular acted as if he didn't even know his wife; not long after, he would run off with another woman. Another senior faculty member in the history department, widely seen as a nice guy, criticized his wife for some small defect in her cooking. Nice guys at the university, I was discovering, were not necessarily nice at home. Even Bill, who was very nice, could be distant and distracted. He was a terrific dad as long as I spelled out what was going on with the kids and exactly what he should do.

The wives of these men were good-looking and intelligent, graduates of good colleges, who were raising children and running households. Many of the wives had interests of their own in politics, the arts, and volunteer work. Wives with PhDs were drawn into working for the dinner-party circuit. Some could not get jobs at the university in their fields—and preparing dinners and serving them to their husbands' colleagues certainly was not the way to get those jobs. Their unpaid, unrecognized work supported their husbands, their departments, and the university at large. But not them.

I found the idea of putting on such dinner parties degrading and, at the same time, intimidating. I didn't have a cache of recipes that I could whip out, and I couldn't turn to my immigrant family for guidance. This turned out to be a good thing, because it opened my eyes to the exploitation of wives in academia. Throughout the '60s, I treaded on tiptoes among these land mines. Although I hosted many evening gatherings, brunches, and dancing parties for our friends, I told Bill when he became chair of the sociology department that I would not be giving dinner parties for his colleagues. He accepted my position and never asked me to do so.

Bill became chair of the sociology department in the mid-'70s. By this time, I had become involved in a women's consciousness-raising group, had helped put on the first women's film festival in Ann Arbor, and had been joined by the

increasing ranks of women with doctorates, few of whom held faculty positions at the University of Michigan. Before Bill took over the department, I told him again that I would not be putting on dinner parties. Nonetheless, I advised him to do something to bring his colleagues together outside of department offices.

We discussed what he might do and decided that he would invite his colleagues to monthly "soirées" at our house on Sunday evenings. I suggested that he provide simple food—cheese, salami, crackers, wine—served buffet-style. One soirée evening when I was late for a meeting at the Residential College, I ran into the first guests, two older couples, as they were arriving. The women wore dresses, stockings, and heels and had purple rinse in their hair. The men wore ties. I could see the surprise on their faces as I hightailed it out of the house in jeans. I felt I was being rude, even though Bill had made it clear to his colleagues in advance that I wouldn't be able to come to all the gatherings. The whole plan fell apart after a few months. I can't say it was a surprise.

"Zelda Baby"

In 1964, Bill got an invitation to be a visiting scholar at the Western Behavioral Sciences Institute (WBSI) in La Jolla, California. Jenny was four and Josh was two, and we decided that it would be fun to spend four months in California. We flew to San Diego with many suitcases, containing, among other things, my Monteith notes and the half-finished first draft of my dissertation.

WBSI set us up in a Spanish-style house with a red tile roof overlooking an ocean cove—and a green Ford convertible with a bumper sticker that read, "All the Way with LBJ." The University of California at San Diego was being planned but still had not yet opened, so La Jolla was a sleepy town filled with retirees, mostly from the navy. With its combinations of palm and pine trees, bougainvillea and eucalyptus, La Jolla was intoxicating.

I felt the sharp contrast between the academic life of Michigan and the non-university institute in La Jolla, California. I had never experienced anything like it. The head of the institute looked like a movie star, with his tan, sailing shoes, and well-cut slacks. I was taken aback and a little flattered when he called

me "Zelda Baby" (though nothing happened). Later, we befriended a political scientist and his wife who had grown up in the Midwest. We hung out together and had good talks about what we were seeing on our first trip to California and, of course, about the presidential contest between Barry Goldwater and Lyndon Johnson.

It was a particular pleasure to see California through Randi's eyes. She was mesmerized by the weather and loved sunning herself on the steps in front of our house with the kids, rather than sitting on the patio inside the courtyard. She wore very short shorts. The few cars on the street in those quiet days slowed down at the unusual sight of a pretty young blond woman sitting with two little kids on the steps of a house. In La Jolla, people did not sit on their steps. We went out to the only decent restaurant in town, a Mexican café, and watched Randi's surprised expression when she tasted hot salsa and chicken mole.

La Jolla could have been distracting, but instead it inspired me to work on my dissertation. The lightness of the place improved the quality of my writing and thinking. I reached a point when I thought I had said all I wanted to say in the dissertation and phoned my adviser, Alex Inkeles, to tell him that I would be sending him the finished draft. I dedicated it to Bill and thanked Randi for all her help in making it possible for me to work on it. A month or so after that, Inkeles called me to say I was done. That was that—no fanfare, no fuss. Since I had not been in touch with Inkeles since my initial dissertation proposal meeting two years before, I was relieved but not entirely happy. Didn't he have any comments, any criticisms? Not really.

After I finished my dissertation, Randi went back to Norway. We stayed in La Jolla two months longer and enjoyed ourselves with the kids and friends. We took outings to San Diego and its environs, especially Tijuana, across the border.

Tijuana could not have been more different from the quiet, somewhat sterile atmosphere of La Jolla: it was noisy, crowded, disorderly, and full of odors. With friends, we would go out at night to dance and drink—fending off offers on the way from young men to set up the guys with their "sisters." We loved going to market day on Saturdays, which reminded me of Marshall Street.

One Saturday, we wandered down the main street and encountered a man who took pictures of children sitting on his donkey. We reached an agreement about the price and arranged for him to take pictures of the kids. Josh went first; I have a picture of him sitting on a saddle with tassels and flowers atop a long-suffering donkey. Josh is smiling slightly. Then we helped Jenny up on the donkey. While we were doing that, Josh disappeared. In a panic, I told Bill to stay with Jenny and I sprinted around the corner and found Josh in a barbershop, sitting on a booster seat and getting a haircut. He wasn't crying and in fact was taking it all in as normal. Apparently, the barber thought Josh's rather long Prince Valiant haircut, à la John-John Kennedy, was too long. I was taken aback but didn't object or argue with him. The man refused to take my money. And thus, Josh's beautiful blond locks were shorn.

I had mixed feelings about returning to Ann Arbor. I had not formed deep friendships in La Jolla and looked forward to going back to friends in Ann Arbor and to life in our neighborhood. But I would miss the ocean, the eucalyptus, and the birds of La Jolla and the market day and sultry nighttime of Tijuana. And I was nervous about returning to Ann Arbor and all the details of ordinary life I would have to handle. I didn't look forward to returning to the house, which I viewed as a drain on my time. Plus, as the Californians often gleefully pointed out, it was January and very cold in Michigan. *And* I would need to find a job. *And* I would have to arrange childcare for both kids.

But I didn't worry too much about these things. Our time in California brought me back to joy—my delight with the kids, my carefree teen years, my sense of good fortune at Antioch, and my closeness to Bill.

I hoped the mood would stay with me for a while. But when it left, as it certainly would, I felt sure I would experience it again. What I didn't expect was that I would find joy in the political activism that became a core part of my life in the years to come, and it remains so to this day.

7

Politics as a Way of Life

When I look back at my political engagement, I know without a doubt that it began with my father, whose politics were central to his identity. Almost every afternoon of his life, after work, he would meet with Jewish cronies—and the occasional Yankee––to talk politics in a Horn and Hardart automat over cups of tea. Creating their own European-style café culture, they would argue passionately about Truman, elections, the USSR, World War II, Jews, and Israel. Their beliefs were left-wing, unionist, anti-Bolshevik and, after the founding of the state, pro-Israel.

My father was a serious student of American history and a staunch believer in the ideals of the founding fathers. He wrote epic poems about America and, to the great embarrassment of us kids, would declaim them in dramatic style. He could repeat passages from Thomas Paine's *Common Sense* and stanzas from Walt Whitman's *Leaves of Grass* by heart.

All this was out in the open. But my father kept hidden two facets of his political history—facets that had an outsized impact on the lives of his wife and children. I didn't learn about any of this until I was in my mid-forties, from his fourth wife, Myra. My father, Myra informed me, had never become a US citizen. This, it turned out, was why he'd been forced to earn money in low-capital businesses like window-cleaning—because they paid him in cash. It was why he

hadn't been able to pursue his dream of becoming a professor or writer, why our family had always had very little money, and why my brother and I both started working when we were kids. Maybe, it was also why all the schemes he dreamed up about becoming a business real estate dealer—I'll never know how he planned to do that kind of business while remaining hidden below the government's radar—never came to fruition.

I never got the full story of why my father didn't become a citizen. When he arrived in the United States, in 1912, he and his two younger siblings must have come on their father's passport. As far as I know, both those siblings did become citizens. Maybe each of them applied for citizenship when they came of age, while my father did not. I'm also not sure what to make of the fact that my father made a point of telling us that he'd voted in every election, and explaining to us in great detail why he voted for Wallace, Stevenson, and Kennedy. Knowing what I do now, I wonder whether he actually voted or if he just wanted us to think he did.

Only in writing this book have I put together the facts about my father's life as a young man with my own experience growing up to find the hidden reality of our family. I learned from Myra that in 1927, my father traveled from Philadelphia to New York City to join the worldwide protests against the executions of the Italian anarchist immigrants Nicola Sacco and Bartolomeo Vanzetti. My father was arrested and threatened with deportation. I don't know how he managed to get out of the situation, but I do know, based on the anti-immigrant fervor of that era and the active deportations then being carried out by local and national governments, police, and the courts, that the threat of deportation was real. And I know from being his daughter that the fear it must have stirred up remained active in him until the end of his life.

That fear drove my father underground. Whether or not he'd been intending to seek citizenship before his arrest, he stayed far away from authorities afterward—and from salaried work. The financial stresses and anxieties caused by his lack of citizenship led to high tensions and fits of temper in our household and, I believe, was a central cause of my parents' breakup. It was definitely what drove

my younger sister, Anita, away from our parents and then her siblings; she doesn't speak to any of us to this day.

Finally, after decades of trying to convince my father to pursue citizenship, Myra figured out how to make him do it. "Sam," she said to him, "you always talk about wanting to go to Israel. But you need a passport to do that. To get a passport, you have to be a citizen. So I'm going to take you to an immigration lawyer."

About my father's continued fears, the immigration lawyer said, "Sam, do you think the government will throw you into jail or send you back at your age? Let's make you a citizen."

When he swore his citizenship, at age eighty, my father was the fattest, oldest, and whitest person in the courtroom. He was insulted by the kindergarten-level question put to him at the final test before being sworn in ... something like who was the vice president of the United States? He became a citizen. Myra got him a passport. Bill and I took him to Israel.

Nobody's Red-Diaper Baby

Despite my father's example of political engagement—the aspects of it that were visible to me as a child, that is——I went through school, and even Antioch, relatively uninterested in politics. In fact, I actively resisted his world, including the left-wing newspaper *PM* that would occasionally show up at our house, brought by my father or his friends. In 1950, when my mother offered to teach me Russian, I flared, "No, I am an Amurrican!" Even at the young age of fourteen, I knew that being an American in the '50s meant that you had to be apolitical. Senator Joe McCarthy was hunting communists at the time, and I knew that studying Russian or showing any connection with left-wing politics would make me a suspect. I wanted to be just another all-American girl who went on dates and had fun, and for a long while, I did just that.

But I wasn't from an all-American family. I was surrounded by artifacts of the old world—my grandmother's samovar, glasses for tea, the ambient sounds of Yiddish and Russian. From the age of six or even before, I knew about World War II, Hitler, and injustice. On Marshall Street, I could see how people struggled

to make a living. The books my father collected were by utopians and leftists—Edward Bellamy, Henry George, Howard Fast, Upton Sinclair, Jack London, Pearl Buck, John Steinbeck. We had records of Paul Robeson, a remarkable singer and performer who became a supporter of the Soviet Union, singing "Joe Hill" and "The Peat-Bog Soldiers" in his unforgettable voice.

As I grew up, my background played out against circumstances that brought me to politics whether I chose it or not. Front and center was an intuitive understanding of injustice just waiting to be turned on. Perhaps because I knew that the Nazis murdered Jews solely because of their "race," I understood that American white supremacists wanted to kill Blacks, whether they said so or not.

Even though Oxford Circle had hardly any Black residents, I did spend time around Black people on Marshall Street who lived nearby and shopped in the neighborhood. Some of the women I fitted with shoes from my grandfather's store were Black. I didn't meet my Uncle Jack, a Black New Yorker from South Carolina, who married my father's sister in the 1930s, or their three sons, until years later, but when I did, we became very close. Throughout my childhood, I was exposed to the poverty-stricken Black neighborhoods of North Philadelphia when we drove through them on our way to Marshall Street. I felt sick to my stomach at the extreme poverty I witnessed and didn't understand why it happened.

There were a handful of African American students at Antioch—most notably Coretta Scott, who later married Martin Luther King, Jr. Yellow Springs may have been a stop on the underground railway but it was close enough to the South to harbor prejudice against Blacks, including Coretta Scott, who encountered resistance from school officials in town to a recommendation from an Antioch instructor that she fulfil her required internship in the Yellow Springs schools. Antioch College stood full-square against racism. When I arrived on campus in 1954, students were still boycotting a barber in town who refused to cut Black students' hair.

My interest in racial politics remained dormant until 1959, when Bill and I moved to Cambridge. Soon after our arrival, Alan Gartner, our friend from Antioch, invited us to join the Boston chapter of the Congress on Racial

Equality (CORE). African American and white members from universities in the area, as well as members of the NAACP from Roxbury, the Black section of Boston, joined together. The group focused on housing discrimination, and Bill and I were immediately drafted to go out on "tests." CORE had a well-developed procedure: a Black couple around our age and of similar financial standing would apply to rent an apartment advertised in the paper. If they were told the apartment was already rented—the typical response—we would apply a few days later. If we were offered the apartment, we used that as evidence of discrimination, and CORE reported it to the Massachusetts Commission Against Discrimination. I was shocked by the blatant discrimination we uncovered through these tests and listened closely to our friends talking about what it was like for African Americans in the United States, including Boston, which was a segregated city with a reputation for racism.

In 1960, a year after we joined CORE, students from North Carolina A&T, a Black college, sat in at a Woolworth's lunch counter in Greensboro because the people behind the counter refused to serve them. Demonstrations at other Woolworth's locations soon erupted in the North, and we participated in demonstrations at the Woolworth's in Harvard Square. When Jenny was a baby, we attached a sign to her carriage that said, "Babies Against Discrimination."

In the late '50s, I volunteered to canvass in Black neighborhoods for the Democratic Party in Ann Arbor. In 2004, when John Kerry ran against George W. Bush, I joined Alan Gartner and a group of Vineyard Democrats in Columbus, Ohio, to get out the vote for Kerry. We chose to go door to door in a working-class Black section of the city. There, we helped voters circumvent tricks that the Republican Party was employing to suppress the African American vote: lying about the date and location of the election and making people wait in long lines on Election Day because not enough voting machines had been provided by the Republican Secretary of State for Ohio, a Black man.

The Peace and Anti-War Movement

I didn't grow up in the peace movement. When Bill and I moved to Cambridge in 1959, I was surprised to learn that while I was living a typical teenager's life in Northeast Philly, our new friends from CORE had spent their early years going to Quaker camps, after-school activities, and social events that emphasized pacifism and the importance of community. Over the years, I came to envy our "red diaper" friends who went to the left-wing Camp Kinderland, knew Pete Seeger and his family, and sang Woody Guthrie songs with their friends and families.

By the late '50s, folk singers had become the troubadours of a new era of political awareness. I did not become involved personally in political activism until 1964, when we returned to Michigan after our time in La Jolla. While we were living the good life, students 500 miles up the coast at the University of California at Berkeley were protesting a university ban on political activities on campus. I learned about the Free Speech Movement (FSM) a week or so after it hit the news in an issue of the *Michigan Daily*, the student newspaper forwarded to us in La Jolla. When we moved back to Ann Arbor, the movement seemed common knowledge, especially among members of Students for a Democratic Society (SDS), who were gearing up as the most important campus activist organization in a generation, founded by Michigan students.

In December 1964, as we moved back, I realized we had a lot of catching up to do. Things were heating up in Vietnam, and SDS in Ann Arbor was awakened to the danger of American involvement. The Gulf of Tonkin incident the previous August, in which the North Vietnamese attacked a US warship in its territorial waters, got their attention because the attack seemed to have been provoked by the United States through its support for South Vietnamese commandos operating in North Vietnam. With more than 15,000 "advisors" sent by the Kennedy administration already on the ground, the expansion of the US role in Vietnam seemed imminent; the Johnson administration was making moves that seemed like preparation for war. I worried that my youngest brother, who was planning to enlist in the navy when he graduated from high school in a few months, would be drawn into the conflict. And he was, leading to miseries—including exposure

to Agent Orange, which resulted in countless health problems, most notably two brain tumors—that he suffered from for the rest of his life.

"We have to do something," I remember telling Bill. We came up with the idea of a strike against "business as usual" at the university—which would mean canceling classes and using the time to focus on the situation in Vietnam. The call for a strike angered state legislators, who immediately pressured the university administrators to stop the strikers. To show they meant business, the Michigan legislature drafted a resolution that censured Bill, the most visible spokesperson for the strike; one legislator even suggested he be given a one-way ticket to Hanoi. (This worried Bill's mother.) After what felt like one too many all-night, coffee-fueled meetings, Bill and a group of faculty chose instead to host a "teach-in." University administrators were so relieved that they didn't have to contend with a strike that they offered ample classroom space and security to conduct the teach-in.

Bill and the anthropologist Eric Wolf organized the teach-in, and I helped by answering the incessant phone calls we received at the house from people who wanted to be involved. I was convinced that the phone was being wiretapped by the FBI—probably not an outlandish idea, given what we now know about the Bureau's habits of surveillance.

Held on a frigid night in March 1965, in an ordinary Michigan lecture hall, the teach-in was no ordinary meeting. The teach-in kicked off with Carl Oglesby, a playwright and actor recently elected president of Students for a Democratic Society, who stepped up to the podium and delivered a riveting speech about American imperialism. Historians with specialties in Southeast Asia taught about the recent history of Vietnam—its occupation by France, the resistance to that occupation led by Ho Chi Minh, and the French withdrawal. Political scientists taught about the geopolitics of the region, with China and Russia and the spread of communism looming large.

The teach-in continued through the night and into the morning. All night long, I could feel the electricity in the room. I felt being *in it*, engaged and ready to throw myself into working to stop a possible war. I had just finished my dissertation

and had two small children at home. At that moment, though, this gathering mattered to me just as much as both of those things. The more I learned about how our government was dragging us into war, the angrier I grew. I felt much as I did when we were involved in CORE a few years before.

After the success of the first teach-in at Michigan, the faculty organizers called their colleagues at other universities to spread the word about holding their own teach-ins on Vietnam. The result was a wildfire of teach-ins across the country, jump-starting the anti-war movement on campuses, from which it gradually reached older and more traditional people over the next decade. I was astounded by campus opposition to the Vietnam War. And I was proud of my role in it.

Looking back, I see that I had turned into a committed activist. I don't understand how this happened in just a few months in 1965 but I can guess why. Political engagement must have been dormant since my childhood. It waited to come out when the historical and personal circumstances supported its emergence. A movement with the participation of people like me—young, passionate, morally outraged, and relatively safe from prosecution—mattered. I had a partner, Bill, whose support and organizational skill I could count on. I could also count on friends who shared my feelings of outrage and willingness to act on them. Our group of friends expanded to include Quakers and people from other liberal churches, as well as the left-wing Jews, colleagues, and students we already knew. Bill and I acquired reputations as leftists in the larger Ann Arbor community. Even our dentist, a tried-and-true Midwestern Republican, knew about the protests at the university against the Vietnam War. While we opened wide and he held the tools of his trade close to our tongues, he lectured us about why we were wrong. Rather than bothering us, this criticism made us feel that we were having an impact. It took a while, but I suspect that our dentist later joined the opposition to the war.

Another expression of my political growth was my role in the Children's Community School, a progressive preschool I founded with Hanne Sonquist, a close friend and another mother, in 1963. Our vision was a school that balanced

experiential learning with solid routines and structure. Jenny joined the Children's Community School for kindergarten in 1965, and Josh a year later for preschool.

Soon, the school attracted campus activists who were interested in education and who later made national headlines: Diana Oughton, a graduate student in education who was a Bryn Mawr graduate, and her boyfriend, Bill Ayers, an undergraduate from Chicago. I was especially fond of Diana, a gentle soul who formed a close relationship with Josh as his teacher. A bit later, Diana and Bill joined the SDS faction that broke off to become the militant Weather Underground. Diana died in 1970 in an explosion in a Greenwich Village town house while she and other Weathermen were building bombs. I was devastated by her loss and have never forgiven the Weather Underground for their role in her death.

The Vietnam War was the driving force of my political engagement until the war ended in 1975. As protests against the war increased in number and intensity, things got ominous. My friend and colleague, Marilyn Young, asked if I wanted to go to the demonstration against the war in Washington, D.C. on May 1, 1971, at the Pentagon. Her friend, the historian Howard Zinn, had invited her and several other left-wing friends to join him at the demonstration. Marilyn and I were in the same women's group and lived close to each other in Burns Park. We both had young children whom we had taken with us to D.C. to demonstrate against the Vietnam War. But a march on the Pentagon was not going to be our usual overnight family bus trip, with beds at the Holiday Inn for the kids to jump on and people holding hands and singing "We Shall Overcome." I could not ignore the potential for violence. I told Marilyn that I'd get back to her after talking it over with Bill. We checked out the organizers of the May Day events and saw that the groups involved in putting it together, like the pacifist War Resisters League, were committed to nonviolence. We agreed that I should go.

The slogan for this protest was, "If the Government Doesn't Stop the War, We Will Stop the Government." It looked as if the government took the organizers at their word: as we flew into National Airport, we saw helicopters and thousands of troops, including paratroopers, the National Guard, and the D.C. police lining the roadways. I wondered what I had gotten myself into. The

city was virtually occupied by the military. It seemed that the government had shored up its defenses after a demonstration four years earlier when protesters succeeded in breaking into Pentagon buildings. Still, I hadn't expected to see so much artillery. It was a graphic picture of the power of the state.

Marilyn and I stayed with Irene Waskow and her husband Arthur, who had spoken at the teach-in in Ann Arbor in 1965. As I looked out the window of the bedroom Marilyn and I were staying in, the brightly lit Washington Monument looked like a giant phallus. By this point in my life, I had taken up yoga, and so I did what I usually did when I was nervous: I stood on my head.

We got a cab early the next morning and picked up Howard Zinn and the linguist and left-wing activist Noam Chomsky. Around 9:00 a.m., the four of us arrived at a designated spot near Dupont Circle to meet up with the five other members of our "affinity group." I was surprised to see Daniel Ellsberg, whom I knew as a Cold War strategist at the RAND Corporation.

The plan was to march to the Pentagon along with the thousands of other people who had converged on the city. We set off together but were soon stopped by soldiers guarding one of the bridges to Arlington. Activists were standing in clusters trying to get through, and others were moving to other bridges and traffic circles. Some were carrying bound pages, which I later learned was a tactical manual produced by the protest's organizers.

Failing to cross, some protesters scattered, while others left the area near the bridge. Our little group returned to the city, but we stuck together. From a grassy area where we sat down, we observed protesters, soldiers, and police as they streaked by.

After a couple of hours, we met I. F. "Izzy" Stone for lunch a few blocks away. Stone, an investigative journalist, had been blackballed from newspapers after writing critical articles about McCarthy and civil rights. Bill and I had been reading his self-published *I. F. Stone's Weekly*, crafted entirely from published sources, so I was excited to meet him. After lunch, he sent our group back into the action. With Ellsberg as our de facto leader, we walked up to the Washington Monument which had freaked me out the night before. Ellsberg, a former Marine

platoon leader and company commander in Vietnam, strode up to the Marines guarding the monument and saluted them. They saluted him back.

We walked aimlessly after that, stopping to observe the scene but never really getting our bearings. At one point as we crossed Dupont Circle, while waiting for the light to turn, a cop guarding the intersection sprayed something into my eyes—mace or pepper spray. He got Ellsberg and me at the same time. Blinded, we held onto each other and stumbled over to a soda fountain at the People's drugstore across the street.

At the time, I couldn't understand why the cop had targeted us. I was a thirty-five-year-old in a raincoat with a kerchief on my head, and Ellsberg, a bit older, was dressed in a jacket and tie. I had thought my tactical choice of dressing the part of a middle-class mom would make me invisible. I later learned that the police were under orders to go after anyone who didn't seem to have any business in D.C.

After we recovered, our group talked about whether we should join others blocking intersections, which protesters were doing in the hope of closing down the city—and the government. I told Marilyn, "I don't see the point of doing that and I don't want to get arrested"—a near certainty under the circumstances.

What did May Day 1971 accomplish? While less confrontational than the Pentagon march four years before, the protest was clearly seen as a substantial threat by the Nixon administration. The deployment of thousands of troops and police was a measure of the administration's insecurity in the face of thousands of nonviolent protesters. The administration orchestrated the arrest of 12,000 protesters, the largest mass arrests of citizens in U.S. history. One of them was Howard Zinn. Most of these arrests were ultimately deemed illegal, and the government was even ordered to pay damages to some people it arrested. It turned out—according to Richard Helms, then head of the CIA, and other members of the Nixon administration—that Nixon and other senior officials saw the protest as very damaging.

A few weeks after we got home, I learned that someone had leaked documents about the hidden history of the US involvement in Vietnam to various

people, including the Institute for Policy Studies, where Arthur Waskow worked. A little while after that, the documents that became known as the Pentagon Papers were on the front pages of the *New York Times* and the *Washington Post*. Something about all this struck me, and I called Marilyn. "Do you think Ellsberg might have leaked those papers?"

Women Strike Back

Another political arena I became involved in was women's rights. I had experienced aspects of sexism my whole life but at first didn't realize it. Once I became awakened to it, I saw it everywhere. In 1969, I joined my first women's consciousness-raising group in Cambridge, at Kris Rosenthal's house. We would go around the circle of about fifteen women, telling each other about our lives. I heard stories about violence and destitution that were hair-raising. I wondered what I had to contribute. Being asked why I should be given a fellowship if I was only going to have a baby? The tale of how I embarrassed my professor when I went to his office with my newborn? Or my woes about being expected to cook for my husband's colleagues? These seemed meager contributions. But then why didn't I talk about the abortion? Or about not being able to get a job in my field at the University of Michigan? I'm still not sure. But at the time, in those meetings, all I could do was listen.

Three years later, when I joined a consciousness-raising group in Ann Arbor. I began to see sexism not only as a personal experience but as a system—much like racism. (The women's movement, in fact, looked to the civil rights movement as a model.) The purpose of the group was to examine harmful social expectations of women and to identify patterns of disregard or active mistreatment. Laws prohibiting abortion, which had the effect of forcing women to risk their lives, exerted the power of the state—controlled, in the 1950s, completely by men—over women's and couples' private decisions. And the nepotism "rule" in universities, which had no legal standing, limited wives' access to academic jobs and kept women from earning their own money.

Much of this system was exposed when a determined group of university women engineered an investigation of sexist labor discrimination in the early '70s. These women collected statistics showing gender disparities in pay, job conditions, and promotion and fed them to the Department of Health, Education and Welfare's Office of Civil Rights (OCR). As a result, the federal government warned the University of Michigan that until the inequalities were corrected, it would stop payment on research grants from Health, Education and Welfare (HEW), the National Science Foundation, and other government agencies. This was the first time that the power of the federal purse was used to stop discrimination in higher education, and it put the fear of God into all research universities across the country.

Eventually, after much foot-dragging, the University of Michigan administration was forced to rectify the salary and promotion disparities between men and women. This was done over the objections of some faculty and departments and took years to implement. Although I lived through this era, even I was shocked at the systemic nature of anti-female bias. The whole sorry story is told in a book by Sara Fitzgerald, *Conquering Heroines: How Women Fought Sex Bias at Michigan and Paved the Way for Title IX* (2020).

At around the same time, I joined a committee appointed by the graduate school that produced a report, "The Higher, The Fewer," which documented women's narrowing job opportunities after they earned their advanced degrees. When I look back at this period, I wonder why it took us so long to see what was going on under our noses. Discrimination against women was part of the general devaluing of women that was deeply embedded in the university system and in society. It took broad social change for women to notice it, let alone name it—and for men to see anything wrong with it. I felt elated when I discovered a letter that my teacher, David Riesman, wrote to one of the University of Michigan organizers on the HEW case:

> *Even very gifted and creative young women are satisfied to assume*
> *that on graduation they will get underpaid ancillary positions . . .*
> *where they are seldom likely to (advance) to real opportunity: A certain*

throttling down occurs, therefore, both in college and later on, which
then, in the usual vicious circle, allows men so mindful to depreciate
women as incapable of higher achievement.

Later, unfortunately, David became quite critical of both the women's move-
ment and the civil rights movement. He was put off by what seemed to him like
too much anger and intemperateness. In this sense, he was a classic liberal, who
believed in the cause but only when it was gone about in a way he deemed civil.
As the son of a successful German Jewish family in Philadelphia, though, he had
little idea of what it was like to be mistreated and bullied.

Bill, too, could not fully understand what it was to be anything other than
a white man from a well-to-do family. When, after years of adapting my academic
interests and appointments to Bill's decisions, I discovered research showing that
women academics married to other academics were habitually limited in their
choices, whereas men were not limited and even benefitted from being married
to other academics, I felt vindicated but angry. I was angry at the system, at Bill,
and at myself for letting it happen to me. When I tried to talk with (or yell at)
Bill about this, he would duck the conflict, commiserating with me as if it were
some distant issue and never thanking me for putting my ambitions behind his.
Looking back now, I wish we could have talked calmly about these matters. Of
course, there were many ways in which I benefitted from my marriage to him—
status, money, the ability to travel. But at the time I could only explode at him,
which scared and put him off.

Israel

When Bill and I first took the kids to Israel, I didn't think of it as a political
journey. It was 1969, a time when Israel was filled with Holocaust survivors, and
life there was a story of survival and victory. It felt as if the curse on Jews had
been lifted. So my relationship to the country began as a sweet and gratifying
one—until much later, when it wasn't.

That first trip, we had an apartment in Emek Refaim, an old Jerusalem neighborhood with a substantial population of Jews from Poland, Russia, and Ukraine, where we met survivors at every turn.

In Ann Arbor, we had gotten to know several of the Israeli graduate students and faculty who were visiting Michigan's sociology and psychology departments. We became especially close to a couple named Rachel and Uri. Uri was a man of obvious intelligence who survived Auschwitz as a young child and grew up on a kibbutz, where he became a leader. Rachel's Moroccan family had lived near the kibbutz and had sent her there to join a youth group, where she'd met Uri.

When we reunited with Rachel and Uri a few weeks after our arrival in Israel, Uri was almost recovered from serious wounds he had received when he and his unit fought their way into Jerusalem in the Six-Day War, two years prior. Unlike many Israelis we met, Uri did not allow himself to rejoice in Israel's victory in the Six-Day War. But he did enjoy traveling with us to hitherto unreachable places like Jericho for fresh orange juice, or the Golan Heights for the views.

We also became friends with sociologists at the Hebrew University and academics in the kibbutz world, who included us in their parties on Shabbat in the late afternoon. While the kibbutz parties were more informal, with children and other family members in attendance, the academics' parties took a particular form. When they arrived at each other's houses, people greeted each other with exclamations of delight, accompanied by kisses on both cheeks and pats on the back. Then everyone sat down in a circle around a table laden with cakes, nuts, olives of various sorts, hummus, crackers, and cheeses. Wine, juices, and seltzer appeared. Then came a deep dive into current events in Israel and abroad, often bolstered by accounts of involvement in government committees and international organizations. Men talked more than the women; to get a word in, women had to turn up the volume. The politics was Labor and left of Labor. The ethnicity was Ashkenazi, with roots in Poland, Russia, Austria, and Germany. I suspect that some of the attendees had spoken Yiddish as children in Europe, but Hebrew was their language now. Out of consideration for Bill and me, various people provided instant translation into English.

The warmth and welcome enveloped me, and I fell in love with the vitality of Israelis, the harsh beauty of the desert, and the green hills of Galilee. I loved the layers of history that Jerusalem enfolded in its golden buildings. I apply this to Jewish and Palestinian Jerusalem alike—the souk in the Old City and the art galleries in Jewish West Jerusalem. Most of all, I was moved by the story of Jewish survival after the Holocaust.

When we returned to Ann Arbor, we sent the kids to a Jewish school for the first time. The teachers at the Jewish Cultural School were Israeli graduate students. In the next few years, the kids also joined Hashomer Hatzair, the "Young Guard," an Israeli scouting group founded in pre–World War II Europe that was supported by left-wing kibbutzim.

Jenny and Josh celebrated their bat and bar mitzvahs in 1973 and 1975, neither a traditional event. Jenny's was a joint affair with other kids from the Jewish Cultural School (JCS), while Josh's bar mitzvah was shared with a friend of his from the neighborhood and the JCS. Both studied diligently with a learned Israeli graduate student, but they did not use him or a rabbi to officiate.

As the bar mitzvah weekend was coming to a close, Josh turned to Bill and asked him, "You don't really like this, do you, Dad?" Bill confirmed Josh's suspicion. In fact, like his own father, Bill had not had a bar mitzvah himself as a boy. Instead, his parents had sent him to the Ethical Culture Society, a humanistic, anti-religion movement founded by a Jew.

Still, our first stay in Israel had planted in both Bill and me an unexpected attachment. After a year or so back in Ann Arbor, I found myself yearning for our friends and for Jerusalem. Bill had a sabbatical year in 1972–73 and we both arranged appointments at the Hebrew University for the year. I taught a course in the school of education about the American higher education system, while Bill taught a course on social movements in the sociology department. In contrast to our 1969 visit, the kids went to regular Israeli schools, where they made friends and built bonfires in the Valley of the Cross, not far from our apartment. As they learned to speak Hebrew like natives, Bill and I struggled in our own Hebrew class. Immigrants from the Soviet Union and Argentina joined us

knowing nothing and, within weeks, were jabbering away in Hebrew, while Bill and I, the professors, remained stuck in the beginner class. It was a blessing that our departments allowed us to teach our own classes in English.

I carried out a study of kibbutz members' aspirations to higher education, using data collected by kibbutz sociologists. My rudimentary Hebrew, plus the better English that most Israelis spoke, got me around the country to carry out interviews with kibbutz policymakers. Also getting me around the country was a blue Volvo we had picked up in Europe on our way to Israel. As I drove around, I kept hearing people yelling out at me. At first, I just heard a series of meaningless Hebrew sounds with no specific words that I could extract. After a month studying Hebrew, I could make out distinct words: *kachol* (blue) *v'* (and) *lavan* (white). But why were people yelling the colors of the Israeli flag at me? I finally asked my friends in Jerusalem, who said it was a sardonic joke that referred to the *lavan* border around our license plate, which everyone knew meant that we didn't pay taxes.

These trips around the country were a great adventure to places I might not have seen otherwise: kibbutzim, one right next to another; the small towns like Afula with Jewish populations from Morocco and other North African countries; the wealthier outskirts of Tel Aviv, along the Mediterranean.

Traveling in my blue-and-white chariot, all the windows cranked open and the radio blasting Israeli popular music, I was in heaven. Here was the thrill—and then some—that I'd felt when we lived for a time in California. Not the least of it was that I met remarkable people, like Shunia, a sixty-five-year-old founding member of a kibbutz in the Carmel mountains from Romania. Like most kibbutzniks, Shunia immediately invited us to stay in his kibbutz for Shabbat. Later, his family would welcome Jenny when she lived in Israel for seven years.

After that year, we traveled to Israel at least every other year. A sense of solidarity propelled me back to Israel after the disastrous 1973 war, in which several friends were wounded. My Hebrew held up enough in 1978 when I joined my friend Tamar in a study of higher education policy in Israel. She conducted the interviews in Hebrew, and I would follow along as best I could. When she saw

my eyes glaze over, she would switch to English. And as with many of our friends, Tami knew the "best" place to get hummus, even in grocery stores attached to gas stations!

Our feelings changed in 2006, when Bill and I visited our closest friend, Judith, an artist who had left Jerusalem for Tel Aviv, as many secular, liberal Israelis were doing. She was living in the old part of the city not far from the Mediterranean, the White City, which was formed of blocks of blindingly white buildings designed in the early part of the twentieth century by modern European architects.

Since our last trip, the ultra-Orthodox population of the country had grown; they occupied more of Jerusalem than they had when we were there twenty-some years ago. We saw them wherever we went in Israel—everywhere except in the kibbutzim. What a sight, if they would have been there! Kibbutzniks taking their ease in shorts and swimsuits on Shabbat, the ultra-Orthodox sweating in their heavy clothes. I asked my friend and colleague, Tami, to drive us around the ultra-Orthodox neighborhoods of Jerusalem. So she interrupted what she was calling "the Corruption Tour," which took us to the city's outskirts, where supersized hotels and apartment buildings had been illegally built atop the hills, and quietly tailed some of the ultra-Orthodox families rushing to a demonstration.

One final experience in the Occupied Territories upset me so much that I vowed I would not go back to Israel again. A friend who volunteered with the women's group Machsom Watch (Checkpoint Watch), which stood at checkpoints to observe how Israeli soldiers were treating Palestinians, arranged for us to tour the West Bank. Our first stop was a lovely settlement on a hill with green lawns and colorful flowers, play spaces for kids, and comfortable-looking houses. Standing with our backs to the settlement, we looked down on parched Palestinian land and drab villages. The contrast was shocking.

Then we drove around the West Bank and stopped to visit a family whose water had been turned off by the Israeli army. My heart broke at every turn, facing the corruption, the heartlessness, and the dehumanization of Palestinians that had become routinized in Israel during the years since we'd last been there.

When I returned home to the Vineyard, before even unpacking, I sat down at my computer and, in a fury, wrote a set of poems, which I later published in the magazine, *Jewish Currents*, "Black Swarm," about the ultra-Orthodox; "White Noise," about life in Tel Aviv; and this one, "A Day in the Life," about the trip to the West Bank.

A Day in the Life

A shimmering town a long way up
Emerald lawns, flowers, playgrounds.
A huddled village a long way down,
Dusty fields, olive trees, rubble.
Down to the valley then a rocky road
Past mud bricks baking in the sun
We sit on an old sofa outdoors
Drinking coffee black and silty
From little cups served
By the wife—the mother of
The strapping sons and the Downs daughter
Who stares at Judy's necklace.
The thin old man shouts through missing teeth
"They tear down our house
We build it again!
"They take away our water
We buy it from a truck!
"They turn off our electricity
We get a generator!
"We will never give up this land!"
Helplessly, we leave
Judy gives the necklace to the girl.
We meet an organizer
Who takes us to a dirt road that the women
Have repaired and swept.
And to a small house

That will be a clinic.

A banner in English: "To exist is to resist."

I also wrote a poem, "Rosh Katan" (small head) about the denial with which Israelis live. I don't blame them for this. In the face of a disaster that I felt I could do nothing about—much like the disaster of the Trump administration—I too would have a *rosh katan*.

Rosh Katan

Don't tell me how bad things are,
I grew up in the Labor Party and it is
No more.
I used to stop for the news every hour,
I used to read three newspapers;
No more.
I go to the beach after work
And dance on the weekends;
The restaurants have gotten great,
It's a good life.
I've taken up tai chi and yoga;
They arc relaxing and fun.
I don't worry so much about
The Situation. The government
Is doing what it has to do.
They protect us.
I don't want to think about it.
What can I do? What can I do?
Yesh li rosh katan. (I have a small head.)
Let's keep it that way.

Climate Politics

Whereas I'd felt pulled into earlier movements by my friends, my entry into climate politics was more of a personal journey. Later in life, after we had moved to

Martha's Vineyard, I started noticing changes in nature that needed explaining, like why some houses were falling into the ocean, and why the monarch butterflies were disappearing. I began hearing about Bill McKibben, who was writing about climate change and raising the alarm that unless we cut back on our use of carbon, climate disruptions were inevitable. I read McKibben's *Eaarth: Making a Life on a Tough New Planet* and Barbara Kingsolver's novel *Flight Behavior* and became more and more alarmed that what seemed like an overarching injustice—that of humans toward the earth—would affect all of humanity. Later, I learned that there were many injustices packed into the larger one; it should not be a surprise that poor people the world over were being harmed by climate changes more than wealthier people, with wars and migrations that could be traced to droughts, rising seas, and more. The bird column in the weekly newspaper, the *Vineyard Gazette*, reported that species of birds that had been common to the island, like certain shore birds, were not around as much as they used to be, while unusual tropical birds would suddenly turn up.

When all of this sank in, my first response was to grieve. But I pulled myself together and reminded myself of the slogan from the '60s: "Don't grieve, organize!" I did what I could to connect with climate change organizations: in 2011, joining the board of the Shalom Center, one of the few Jewish organizations at the time devoted to Judaism and the environment. The Shalom Center's leader was Arthur Waskow, our old friend, who had become a rabbi later in life. At a board discussion of the mission of the Shalom Center, I suggested that we place climate change at the center of our work. My idea was adopted.

When I heard about the People's Climate March, to be held in New York City on September 21, 2014, I just had to go. Much time had passed since I marched in a demonstration. By then, I had become a grandmother. I needed to do this for my five grandkids.

My climate march started out with the faith communities assembled near Columbus Circle. At 11:30 a.m., a friend and I got off the subway and walked toward 58th Street, where we were hailed by march greeters who treated us like old friends. We waded into a crowd of Catholics and Capuchin monks in brown

robes, Muslims, Jews wearing yarmulkes, Buddhists in saffron robes, Methodists, Episcopalians, Quakers, and many others. Immediately, old friends and acquaintances grabbed for us through the crowd. I looked for Rabbi Waskow and located him on a stage with musicians and various people of the cloth. Next to the stage was a tall inflatable mosque, and on the other side, a wooden Noah's Ark, the size of a small school bus.

The marchers filled two city blocks, singing ("We Shall Overcome," "Halleluiah," and "This Little Light of Mine"), flying inflatable art, and generally having a good time. At 1:00 p.m., we were shushed to a moment of silence, followed by blasts from trumpets, whistles, tubas, drumbeats, whoops, and cries intended to raise an alarm about climate change. Several people blasted shofars, the ram's horn blown to usher in the Jewish new year.

When I had a chance to peel off from the group, I found a good spot to watch the rest of the march go by. That was when I could really see the spectacle we had all created. From side streets running from 86th Street to our crowd at 58th, people on foot joined those with wheelchairs, strollers, bikes, scooters, and roller skates. Into the march came neighborhoods and towns, scientists, beekeepers and organic farmers, wildlife preservationists and protectors of the oceans, veterans, unions, peace and justice groups, anti-fracking and anti–tar sands groups, anti–nuclear power groups, students and youth, elders, Canadians, Indigenous peoples, musicians and artists, and Hurricane Sandy survivors.

They rode on homemade floats. They carried life preservers, balloons, pennants, umbrellas, and signs ("Don't Frack with Us," "There Is No Planet B," "Love Your Mother," and "Repair the Earth") and floated globes. They wore homemade animal costumes. Some wore almost nothing, like the grass-skirted guy whose bare chest proclaimed "I Am Burning Up" in orange paint. Floating above them were swans, geese, polar bears, reindeer, and a belching cow. The *New York Times* reported that a group of Japanese ice sculptors had carved a 3,000-pound ice sculpture titled *The Future* which they carried from Queens to Manhattan as it melted. I was especially struck by a block-long banner held by many people

which said, "Flood Wall Street." Occupy Wall Street used the banner the next day on Wall Street, in an action that resulted in some arrests.

Exhausted, I limped over to Columbus Circle and climbed down into the dark and steamy subway to meet my friends downtown.

I cannot imagine being alive without engaging with politics. Neither could Bill. Both of us shifted and shaped our professional work in ways that reflected our convictions and involvements, he in studies of political movements (such as *Encounters with Unjust Authority* and *Talking Politics*), and I in the deeply anti-elitist stance of what I chose to study, teach, and fight for in my work, as I detail in the following chapter.

These days, I continue feeling red-hot rage about the arrogance of very wealthy people, about brutality toward people of color and LGBTQ+ people, about the exploitation of women. This rage fuels my sense of injustice. But I remind myself that I cannot stop at rage. Even as an old woman, I know I must engage with the people who are fighting against these injustices. I cannot do it myself; I need them. I join the organizations that work for change. I sign the petitions that come my way against money in politics, surveillance, and voter suppression. I join up with others to make phone calls and send postcards to voters to get out the vote for candidates who will make a difference, as in the presidential election of 2020 and the Senate runoffs in Georgia that year. I contribute whatever I can afford to organizations like the American Civil Liberties Union (ACLU), the Southern Poverty Law Center (SPLC), and the Natural Resources Defense Council (NRDC) that will fight for what I think is right. I go to demonstrations and rallies even if I cannot finish the march.

To keep going, I have taken to repeating the words, "Justice, justice shall you pursue" (Deuteronomy 16:20). "Pursuing" justice means in this life, not in some hazy future. I am proud to say that there is very deep support for resistance to injustice in Judaism, particularly in the prophets, who do not mince words. Jeremiah (5:28) rebukes the Jewish people when they fail to plead the cause of the orphan or help those in need. He scolds an entire generation: "In your skirts is found the blood of the souls of the innocent poor" (2:34). Ezekiel rebukes the

whole Jewish nation for "using oppression, robbing, defrauding the poor and the needy, and extorting from the stranger" (22:29). Isaiah and Micah castigate Jews who grow wealthy at the expense of their neighbors. Amos tells humanity that without justice in the world, God is angry. Speaking for God, Amos says:

> Take away from Me the noise of your songs
> And let Me not hear the melody of your stringed instruments,
> but let justice well up as waters,
> and righteousness as a mighty stream. (5:23–24)

I cannot resist the prophets. They speak for me, they give me hope, they lift me up. I feel hope and joy well up inside me, especially when I am standing alongside others, working together to make a more just and righteous world.

Putting My Values to Work

"YOU ARE SUCH A WORKHORSE."

So said my mother-in-law as she lay dying in a hospital bed I had set up for her in my study in 1985. This was a word I had never heard before, but I knew it wasn't meant as a compliment. Though I did not agree with my mother-in-law about many things—by that point, I had done everything I could to make her comfortable in my home, yet she still had only barbed words for me––I had to agree that I had become a workhorse, and a frantic one at that. Perhaps I was more like a chicken without a head, as my daughter observed one day as I jumped from making dinner to filing papers to feeding the dog and back to the kitchen.

I didn't start out that way; it took me some time to become a world-class workhorse. For the first five or so years after finishing my PhD, I had a half-time job, but as I gradually took on other part-time jobs, I usually held two half-time appointments and a number of extra projects. Plus political and civic involvements. I *chose* to do these things, each one at a time; added up, they made for a very busy life. Count family and friends into the mix, and I *had* to gallop through my life.

I did not have a conventional academic career, like Bill's; I didn't lay out a set of goals and I didn't follow a single path. Instead, I followed interesting opportunities wherever they led me. I am someone who likes adventure and

learning something new. When I read an essay called "The Hedgehog and the Fox" by the political theorist Isaiah Berlin, I recognized immediately which one was me. The hedgehog, in Berlin's framing, looks at the world through a single lens, whereas the fox, moving fast, going here and going there, knows a lot of things but not deeply. Standard academic life rewards hedgehogs, and certainly, at the beginning of my career, I tried to be one. I resisted my foxy ways. But there is only so much we can do to change our natures.

One thing I did always know, which helped me find my own kind of focus, was that I love colleges and universities. I love the buildings, the undergraduates, the travel, the summers off. Also the curiosity and search for knowledge, the playfulness, the vision of a better life. I wanted to protect the higher education community and help it live up to its ideals.

The other force that guided me in my work was my lifelong preference for immigrants, working-class people, and people of color, along with a healthy dose of suspicion of very rich people and institutions. In a way, just like my mother and father. My childhood taught me to value egalitarianism along with community, and this drew me to certain projects and organizations and turned me away from others.

Let me tell you about my work over the years and see if it all makes sense.

A Little Help from My Friends: The Michigan Student Study

When we got back to Ann Arbor from La Jolla in the fall of 1964, I knew it was time to look for a job. After getting Jenny and Josh settled into preschool and daycare, I turned my thoughts to the Michigan sociology department, my first choice for a teaching position.

Years earlier, one of my professors in the sociology Master's program, Guy Swanson, had offhandedly suggested as we were preparing to move to Cambridge, that I might think about teaching in the Michigan department when I finished my doctorate. I remember being taken aback at the time because I felt that it was way too soon for me to think about a job when my doctorate was in the hazy distance.

After three years in Cambridge and back in Ann Arbor where I finished my dissertation, I asked Bill whether he thought I should speak to Swanson, now the department chair, about potential job openings. In those days, such jobs were not advertised; instead, they were usually filled upon the recommendation of the chair of the dissertation committee or a member of the department where the candidate was a graduate student. I didn't know if there even was a job in the sociology department that would fit my specialties in organizational behavior and higher education. But if there were such a job, the typical procedure would have been for Swanson to call Alex Inkeles, my dissertation chair, to ask for his recommendation.

This way of selecting faculty in the 1950s and 1960s ensured that almost all the jobs in academia, especially at elite schools, would be held by white men. It was man to man to business, and a male faculty member considering recommending a woman for an open position would have to be willing to buck the well-established old-boy system. The result was that the good academic jobs in the major disciplines were locked in for decades by white men who held tenure and no requirement to retire. In the late '60s, when jobs became scarcer, the next generation faced a much tighter academic job market, and by 1972, when the federal government required universities to advertise jobs, thus giving women a shot at tenure-track positions, those jobs were scarce. Yes, women had a little more access to academic jobs than they did before, but they tended to be in limited-term appointments with titles like "lecturer" or "instructor."

But back to Bill. Did he think I should ask about a job? His response was noncommittal. It would have put him in a difficult position if I asked him to put in a word for me and I did not want to do that. I felt awkward talking to him about my own career, and I wanted to avoid embarrassment for both of us if I didn't get a position, which seemed likely. I guess, at that point, I was unwilling to fight the bias that drove the academic system against women. There was not yet an active women's movement that might have given me the strength to try for an appointment in the face of Bill's reticence and my unwillingness to press the issue. (*Maybe I should have done so, I tell myself now.*)

I was also unwilling to run the gauntlet that I saw other wives of faculty endure in departments like history, geography, astronomy, and other disciplines. I did not want to be a "conquering heroine," like the women described in Sara Fitzgerald's book with the same title. One such heroine, a close friend of mine with young children whose husband was tenured at Michigan, took a job at a local college nearby, where wives of faculty at the University of Michigan were often channeled. When she applied for a position at Michigan in the history department, she was treated shabbily. She then made the difficult decision to accept a tenured position at the University of California, while her husband remained in Ann Arbor.

Conquering Heroines demonstrates how impossible it was for wives to get appointments in the same departments as their husbands. For all the obstacles that faced them, the most insulting were the unexamined assumptions behind the widely-used nepotism "rule." There was no standard application of that "rule," just that it was set up to avoid favoritism of an unexplained kind—almost always involving a spouse, fiancée, or partner. In the period I am describing, the result was that wives were closed out of positions in the same departments as their husbands, even if they were more senior, had a better publication record, or held a degree from a more prestigious university.

More happily, I decided to attend my PhD ceremony in Cambridge. I had skipped my Michigan BA and MA graduation ceremonies years before and didn't want to miss this one. It was 1965, and Bill was in D.C. for a national teach-in, so I decided to go to Cambridge and then Philadelphia alone with the kids. I made it an adventure by taking the overnight train to the East Coast. We tucked ourselves into a cozy sleeper car, something I had always wanted to do. I remember the trip fondly—watching the scenery flash by while reading *Winnie the Pooh* to Jenny and Josh. When we got to Cambridge, we stayed with my old friend, Kris, who drove us to the Harvard commencement ceremony. As I went up to receive my degree, I heard five-year-old Jenny crying. Kris tried to comfort her but failed. I received my doctorate to the tune of "Mommyyyyyyyyy!

When Jenny, Josh, and I reached Philly by train, we went to Loretto Avenue to stay with my mother. That night, I tripped on a throw rug in the living room and landed on my left elbow. After an excruciating night, I left the kids with my mother the next morning and somehow got to Jefferson Hospital, where the broken parts of my elbow were gathered in surgery. I did not want to disturb Bill at the Washington teach-in so I did not tell him what had happened until he arrived from D.C. as planned. He then took over the care of the kids. I don't remember how we got back to Ann Arbor since I was still in a fog from painkillers.

Once I was out of a sling, I turned back to finding a job. I never ended up talking to Swanson about a faculty position in the sociology department, but I quietly let friends know that I was looking for work at the university. I soon heard that Gerald Gurin, a social psychologist at the Survey Research Center (SRC), was looking for a researcher to join his program on student development in college. I was not new at the SRC, having worked in the coding department as an Antioch co-op student and, later, with Libby Douvan as a research assistant. Libby recommended me to Jerry, a longtime colleague and friend. No question that I benefitted from the informal way people got jobs in those days. Instead of the old boys, I had a network of friends who were watching out for me.

The Survey Research Center was home to the Michigan Student Study, a treasure trove of information gathered at several points in students' lives during the 1960s. In reactions like those I felt about studying the organizational setting for students' impact on Monteith College for my dissertation, I realized that I was less interested in studying student development and more in the environment that surrounded students at Michigan; I was drawn especially to student organizations mediating the influence of the university on students. My initial impulse was to study political organizations on campus, especially as the anti-war movement was gathering steam. I was intrigued by the growth of the left-wing Students for a Democratic Society and was curious about the Young Americans for Freedom, the right-wing group. Meanwhile, the Young Republicans and Young Democrats occupied an important position between SDS and YAF. As a kind of comparison, I wanted to understand the role of religious groups on a secular

campus. Less interesting were fraternities and sororities, but I knew that Greek life was dominant at Michigan. It would be a grave omission to exclude them.

In an act of chutzpah, I proposed to Gurin that instead of using the data from the Michigan Student Study, I look at the extracurricular side of student life. He never said anything to me about changing the job he had hired me to do, but he did say that it would be okay for me to set up my own research project within the Michigan Student Study if I could raise my own money, including my salary. I gulped and said I would try. Thus, I learned soon after receiving my PhD, how to write a grant proposal, which I would continue to do for the rest of my career. With coaching from Jerry, I found that writing a grant proposal came easily to me. My training in philosophy helped me construct an argument about why the proposed research filled several gaps in knowledge. Armed with a detailed analysis of several streams of previous research, with flowcharts showing what I proposed to do, I secured a large grant from the National Science Foundation to study student organizations as spaces that shaped and mediated students' relationships with a large, complex university. (Total Michigan enrollment in 1965 stood at 15,000 undergraduates and 10,000 graduate students.)

As a result, I created one of the few studies of student extracurricular life across a broad spectrum, which included five religious organizations, including the Catholic Newman Center, Hillel, an evangelical group, a liberal Protestant group, and a Methodist organization; nine sororities and nine fraternities; and the four political organizations I have already mentioned. My study was unusual for combining questionnaires with in-depth interviews with the leaders in these organizations.

With the help of an assistant, I attended meetings and conducted long interviews with the groups' leaders. We treated the interviewees as informants about their organizations, much as anthropologists do in the field. In this research design, we departed from the methods of survey research, where data are collected anonymously and at arm's length in large samples to allow accurate generalization, and where, in the hands of a talented analyst, the story to be found in the data is teased out using statistical analysis and mathematical models.

I discovered, as I did in my research at Monteith College, that my talent lay in qualitative research. The "story" was perhaps easier to access in qualitative than in quantitative research, although I still found that I had to wrestle it out of a large pile of interviews and observations. But it was even more challenging for me to wade through endless tables and try to make some sense of them. Despite winning the statistics prize at Harvard, I wasn't good at statistical analysis—and I didn't enjoy it.

To be clear, I was never against quantitative research; it just didn't suit me. I was always more comfortable with interviewing because I saw it as a chance to learn directly from people who were experiencing what interested me. There was another reason: in the student organizations project, I was interested in organizations, not in individuals. While individuals in surveys are frequently aggregated to describe organizations, I did not trust these studies to accurately describe matters like the distribution of power or how organizations operate in a larger environment. There are organizational variables, in other words, that cannot be reduced to individual ones.

On a more personal note, I realize now that the student organizations study completed my own missing extracurricular life, something I had not experienced as a married undergraduate at Michigan. Just a few blocks from my house and all my adult responsibilities, I found it liberating to immerse myself in the activities of campus groups.

As activism intensified across the country through the '60s, I was invited to present my work at academic conferences. I mark this now as the moment when my personal values began to converge more consciously with my academic work. I had the benefit of quantitative data from the larger Michigan Student Study. In 1965, we designed a second study, to which I contributed questions about student attitudes toward the Vietnam War and student involvement in university decision-making. Using these questions, I wrote a paper on four kinds of students: (1) student activists, (2) bystanders who shared the activists' views but didn't act on them, (3) students who were neutral, and (4) students who disagreed with the activists.

I deployed my knowledge from these studies to construct a deeper analysis of the nature of student activism at Michigan. In 1973, I contributed a chapter titled "Michigan Muddles Through," to a book published by the Carnegie Commission on Higher Education about student activism on several campuses. In the chapter, I drew on my research on student organizations and the Michigan Student Study and embedded them in a picture of the University of Michigan which helped me explain why activism at Michigan was less hard-edged than on campuses like Berkeley and Columbia. I interviewed senior administrators and faculty leaders about how they saw the anti-war demonstrations and Black students' protests. What became clear was that Michigan was an interwoven campus, where close connections between administrators and faculty and regular interactions between students and faculty built resilience during difficult times. The fact that the original teach-in was led at Michigan by faculty, with support from administrators and full participation by Students for a Democratic Society, created the foundation that helped Michigan survive and even thrive during the '60s.

For example, during protests on campus, faculty turned out in significant numbers to act as peacekeepers on the streets of Ann Arbor. And in a months-long campaign to raise the enrollment of Black students significantly, create a Black student center, and increase financial aid, the Black Action Movement (BAM) pressed the university hard, with a strike that shut down classes. When negotiations broke down between the law school students who were leading BAM and President Robben Fleming, a professional arbitrator, the breakdown was not irreparable. Both sides managed to maintain some degree of contact and ended up reaching a compromise agreement.

The Center for the Study of Higher Education

As our research at the Survey Research Center was winding down, Jerry Gurin recommended me for a tenure-track appointment as an assistant professor in the Center for the Study of Higher Education (CSHE), where he also taught. I had no other prospects and felt the position was worth trying. I was intrigued

by the fact that CSHE was the first doctoral program in higher education in the country. And I was pleasantly surprised when I learned that a former president of Antioch College, Algo Henderson, had founded it.

And so I joined a small group of middle-aged white male faculty members, mostly from the Midwest. Jerry and I were the only Jews; a few years later, a Black man joined the faculty, and the three of us loosened up the place. The students were similarly homogeneous—there were very few women, people of color, or Jews. The faculty didn't seem comfortable around me at first. I had no experience as an administrator or, for that matter, as a faculty member. I couldn't gossip with them. It took us about a year to adjust to one another but then we became a good working group, carrying out research and developing the curriculum.

As a new field, the study of higher education stretched out to several disciplines. It seemed to me a kind of academic Wild West, where higher education faculty from different disciplines—sociology, psychology, economics, history, the humanities—were creating the field as they went along. Having grown up in philosophy and sociology at Michigan and the inter-departmental Department of Social Relations at Harvard, I realized very soon that the world of the center was different from those departments: the field of higher education had a professional rather than academic identity, like business or social work. The goal was to train thoughtful administrators who could put ideas from several disciplines into practice.

I would have done well to join the grad students, some older than I was, in their courses on the history of higher education, the structure and culture of different kinds of colleges and universities, and on education finance and public policy. I boned up on these subjects in a big hurry, reading Frederick Rudolph's history of higher education, *The American College and University*; Arthur Chickering's *Education and Identity*, about student development in college; and *The American College*, edited by the psychologist Nevitt Sanford, with chapters by my friends, Libby Douvan and Carol Kaye, by my sponsor David Riesman, and by two dozen other authors from psychology, philosophy, anthropology, and other disciplines. Read together, these analysts made the study of higher education intellectually

exciting. Middle-class Americans expected that their children would go to college, and the Michigan program had much to offer as colleges and universities expanded to meet the demand.

The faculty at the center agreed to my request for a half-time appointment, a model for married academic women with children—I could bike home to give lunch to Jenny and Josh and be there when they got back from school.

The faculty also agreed to let me teach a course on innovations in higher education, which became my signature class. My students and I struggled to understand the periodic appearance of experiments like Monteith College at Wayne State, as well as the occasional freestanding experiments like Black Mountain and Antioch. Which factors drove their emergence? How did they survive in spite of very limited funds, competition for students and money, and frequent internal conflict? Did they influence other schools? I have tried to answer these questions my entire career, because I saw experimental colleges as offering lessons that the rest of higher education could learn.

At the time, I didn't realize that I was helping to establish the field of higher education. I just followed my instincts and took on a project, finished it, then turned to another. In the process, I continued to learn new things, meet different casts of characters, and make new friends. The center became the base for many of my research projects and external involvements. With two colleagues, Marvin Peterson and Robert Blackburn, and three graduate students, I helped design and carry out a study of Black students on thirteen predominantly white campuses. The book that we co-authored, *Black Students on White Campuses: The Impacts of Increased Black Enrollments*, was published in 1978.

In my thirty-some years as a teacher and researcher, I witnessed the expansion of the study of higher education, with doctoral programs popping up across the country. The graduates of the Michigan program had a head start and took on leadership positions in national associations, at federal and state agencies, and as administrators in colleges and universities around the country. When I started at the Center, *Change* magazine focused on doings in higher education and the

beautifully constructed weekly newspaper, the *Chronicle of Higher Education,* had just gotten under way.

The Residential College

While teaching about these matters at the graduate level, I felt I needed the understanding that could come from actually *doing* what I was teaching. I was fortunate to have at hand—literally across the street from the School of Education—an experimental college that had many of the markers of progressive education at the time: interdisciplinary programs, freshman seminars taught by faculty from different disciplines, senior seminars, and a living-learning community. The Residential College (RC) became a haven for creative writers, artists in theater, studio arts and music, many of them faculty wives like me who could not find jobs in their academic fields at the university. Some were brilliant teachers, others creative designers of programs, and a few hard-nosed administrators.

In 1973, I accepted a half-time job as an associate director at the RC and never looked back. Within a few months, I felt like an old hand. I joined a newly appointed director, a lovely man from the physics department with little administrative experience, who needed my help. I knew some of the senior faculty who had founded the RC and some friends on the faculty from Burns Park like Marilyn Young and Kitty Sklar.

I felt immediately at home at the RC, which reminded me of Antioch, with its activist politics and its artistic, playful community. Dress was one way of marking those differences. Going from my class or a meeting at the School of Education to the RC, I managed a quick change in an ed school bathroom from a skirt to pants—a code switch, again, as I'd perfected when my brother gave me my first pair of dungarees.

After several years at the RC, I helped design the Student–Faculty Research Community (SFRC), which put into action some of my ideas about what made education powerful: intensity, collaboration, and meaningful subject matter. The SFRC consisted of three teams of six to eight students working with a single faculty member on an original research project. It was a demanding program that

required students to dedicate a minimum of twenty hours a week to the project, which meant they were permitted to enroll in only one other course during the semester. Some students dropped out of the program, complaining about its intensity. Most stayed with it.

In the second year of the SFRC, I decided to plunge into one of the research teams myself. Six students and I carried out a study of co-ops, one of them a food co-op located in a downtown neighborhood in Ann Arbor, an experience that wound up influencing my work and political thinking in years to follow, when I began to explore worker cooperatives as possible democratic solutions to underemployment and unemployment. During the SFRC project, I began to correspond with co-op activists and read all I could about the history and current situation of co-ops in this country and others, which led me to several interesting economists. I joined one of them, Henry Levin, and his co-author, Robert Jackall, in contributing a chapter to a book on worker cooperatives in America.

As I reflect on this stage in my career, I see that I found niches at the University of Michigan like the Survey Research Center, the Center for the Study of Higher Education, and the Residential College that allowed me not only to do interesting work with almost complete freedom and a modicum of status but to also lean into ideas and projects that aligned with my values. I am grateful for these opportunities to this day. They saved my sanity and my marriage, as Bill's life settled into a calm, predictable groove while I struggled, and then succeeded, in finding a place—or rather, places—for myself.

At the same time, I was spreading my wings beyond the university. Eventually, I would fly away entirely.

Opportunities Knocked

In those early years, I became a close ally of the Fund for the Improvement of Postsecondary Education (FIPSE) of the US Department of Education, which attracted some of the most thoughtful people in the Education Department. My standing at Michigan gave me access to several FIPSE grants, including a multi-institutional study of competence-based education, which resulted in a

book, *On Competence,* co-authored with David Riesman and other collaborators from different universities.

In addition, on the recommendation of a higher education colleague, in 1979, I applied for and was selected to direct another project funded by FIPSE. That project, titled "Examining the Varieties of Liberal Education," brought me into close contact with faculty members from fourteen very different colleges and universities doing all kinds of things that FIPSE thought might open up the meaning of liberal education.

As director, I ran a complicated three-ring circus that brought these faculty together regularly to talk about their programs. Initially, I felt my responsibility was to lead the group toward agreement about the meaning of liberal education, but I immediately ran into obstacles: some in the group rejected the very idea that there could be a common understanding across the fourteen programs. Others were game to try but found it a difficult assignment. After several excruciating attempts and with another headache-inducing meeting coming up, I asked an advisor to the project what I should do. He responded with a question, "Do you feel affection toward each other?" When I answered, "Of course," he said, "Then that's half the battle."

An unexpected breakthrough came when jazz musician Ken McIntyre, the head of the African American music program at SUNY-Old Westbury, asked for some time on the agenda. I agreed reluctantly, wondering what he wanted to do. McIntyre said to the group, "I start my jazz classes with the students tapping their fingers to different beats. So, here's one I'd like all of you to try." It was a simple 4/4 beat. The group gamely tapped the beat on the little desks attached to their chairs. "Okay, good," Ken said. "Let's slow down the beat and emphasize different notes. I'll tap it out, and you can repeat it." The group did what Ken asked, all tapping slower—except me. I was impatient with what seemed like a distraction and wanted to return to the agenda. Ken turned to me and said quietly, "Slow down, Zee."

At that point, a lightbulb lit up for me. I understood that Ken was demonstrating through music what was happening in the meetings: the group worked

well together, but I was too impatient, pushing them too hard to agree. In fact, we did not need to agree. Built into the title of the project was the word "varieties." Nobody had asked me to find a common meaning. I had imposed that task on myself and everyone else—and it proved fruitless. After Ken's lesson, I took a deep breath, scrapped the agenda, and started listening deeply.

In the early 1980s, I decided to write a book, along with several of the participants, about what we had learned about the varieties of liberal education. As I sat in my recently completed house on Martha's Vineyard, reading transcripts of interviews with students and instructors in the fourteen programs, I searched for often buried themes and principles of education. A common theme emerged: the transformative power of education in these peoples' lives.

Some examples:

- A seventy-five-year-old woman in a class for seniors said of her experience in classes at the New York City Technical Institute, "I learned that my mind has a mind."

- A twenty-eight-year-old shipping clerk from Queens, New York, remarked, "You become more active, more aware of people. You become sensitive and objective. You can take a stand. You become positive about life. If something goes wrong, you don't blame yourself."

- A young mother in Vermont's External Degree Program at Johnson State College reported, "Everyone's husbands were paranoid at first, mine included. They were concerned that it would make us more 'liberal.' But I do think more, I see a broader range of possibilities for action. I'm less judgmental. I use my leisure time now to learn something rather than parking myself in front of a TV."

I eventually called the kind of education that produced these results "liberating education," which became the title of my book. Writing *Liberating Education* (1984) was a transformative experience for me, much like my life at Antioch College, my fascination with language, and my love of music. Re-reading the book fills me with love for the people I met in the project; I can feel in the prose my passion for the ideas in it.

The Seven Principles

My involvement in these projects inspired what was probably my most important contribution to improving undergraduate education. On most campuses, I knew that there were faculty members who were eager to enliven their classes and challenge themselves to do a better job. I also knew that a majority of faculty had discretion about what and how to teach and so were free to change the way they taught. Rather than trying to publish a paper written in an education journal hardly any undergraduate instructors would read, it made sense to try to talk to faculty directly and in plain language. Given the well-known psychological principle that people can remember at most seven items at a sitting, my initial vision was to print principles of good teaching on a card small enough for a faculty member to carry around in a wallet or jacket pocket.

I wanted these principles to be based on research. Working with the psychologist Arthur Chickering, who had written several influential books on higher education, we gathered a group of researchers on undergraduate education who volunteered their time to come up with principles of good teaching that were supported by research. Chickering and I worked through the notes of the meeting and proposed about a dozen principles for good teaching. Several drafts flew back and forth across the country, until we ended up with the "Seven Principles for Good Practice in Undergraduate Education." We decided that a good instructor:

1. Encourages contact between students and faculty

2. Encourages cooperation among students

3. Encourages active learning

4. Gives prompt feedback

5. Emphasizes time on task

6. Communicates high expectations

7. Respects diverse talents and ways of learning

The Johnson Foundation of Indiana printed and distributed many thousands of copies of a newsletter-style publication with teaching examples supporting each principle. These were distributed to colleges and universities across the country.

To make it easy for faculty, graduate students, and researchers to adapt the Seven Principles to their own uses, they were never copyrighted. Chickering and I did the work on our own time, without grant money, with the gift of time from our research colleagues and contributions from the Johnson Foundation. Today, the Seven Principles are still cited by teachers and researchers in most imaginable fields like health education, computer science, and philosophy in colleges and universities in US, Japan, England, Germany, Peru, and other places.

Taking to the Road, Island-Style

By the early 1980s, our children were on their own, and Bill and I were living alone in the family house in Ann Arbor. In 1975, when the price of land was affordable, we bought three and a half acres, just over the minimum acreage required in Chilmark. We saved money to build a house. Construction began in 1979, and in 1981, our house was completed. We felt pulled to the East Coast, where Josh had moved for college, and I decided that I could make a small living from consulting work, which I could do from anywhere. We asked for two-year leaves of absence from our tenured full professorships at Michigan, and when it was clear that we would stay, we chose a home base in Boston, as Bill was being recruited by the sociology department at Boston College. In 1984, we settled in a five-story house in Boston's South End, with its rows of 19th century bow-front houses. The neighborhood had not yet been gentrified and turned into condominiums by the empty nesters and hipsters who would later change the face of one of the city's relatively inexpensive places to live, home to mostly Black families.

The trip from Boston to the Vineyard took about three hours, so it was quite possible to commute a few days a week and stay overnight in either place. As usual, I didn't have a plan, but I had a strong feeling that it would work out well. One day, I woke up and realized that consulting didn't require that I spend all week in Boston—in fact, I didn't have to be in Boston at all if I didn't want to be. I began flying out of the single-gate Vineyard airport, through Boston, to destinations all over the country.

From my home base on the Vineyard, I became involved in a variety of consulting projects that grew out of the Seven Principles. I traveled constantly for a while, giving speeches at conferences, staying on campuses as a resident observer and consultant, sleeping in dorm rooms and hotels, talking and listening. I was meeting wonderful faculty members in non-elite colleges in out-of-the-way places. They cared about their students and about the future of their institutions. I helped them apply for grants to try out different teaching approaches. These faculty were often criticized by their colleagues for being "different," and I would defend them and offer evidence that supported their ideas.

University of Massachusetts Boston:
New England Resource Center for Higher Education

Then, after six years of consulting, I grew weary of packing and unpacking. I was tired of having to buy business-style clothes. I knew I really needed to be on a campus again. Around that time, I read an article in *Change* magazine by Ernest Lynton, who had been the academic vice president for the University of Massachusetts system, about how undergraduate education could do more to introduce students to the world of work. I called Lynton to say I found his article in tune with my ideas and proposed a meeting. On the phone, I'd noticed his accent, and when I arrived at his spacious Brookline home, I was met by a short, elegant gentleman with abundant white hair. A physicist, Lynton was the founding dean of Livingston College, an experimental college at Rutgers University. A bon vivant of sorts, he drove me home in a convertible, and we talked about his escape from Nazi Germany in his youth and how he met his wife, from a Jewish family in Holland.

Several months later, in the fall of 1987, Lynton proposed that I apply for a position at the University of Massachusetts Boston (UMB) to build a regional resource center for higher education in New England that would be affiliated with national higher education organizations. He warned me that the position was only funded for three years and, as a non-teaching position, it did not include tenure. I held a full professorship at the University of Michigan by then, but I

told him that I didn't believe in tenure, because too many senior faculty, almost all white men, were holding jobs that should rightly go to younger people, especially women. I was so angry at the system at that point that I felt I was liberating myself by giving up tenure. I remember saying breezily, "Easy come, easy go." I was naïve: bravado notwithstanding, I stood for tenure a bit later so that I could teach at UMB in a program I had created!

As I settled in at the University of Massachusetts Boston, I began to see many inequalities within the US system of higher education. Coming from the University of Michigan, Harvard, Antioch College, and the University of Pennsylvania, I had only experienced name-brand higher education—where students were *selected* rather than just admitted, where work life was pleasant if not opulent, and where respect was a given.

At public institutions, on the other hand, cutbacks in support by state governments often meant that innovation was sacrificed when money grew scarce. State universities, regional state colleges, community colleges, and even unknown private colleges struggled constantly with money problems, loading their regular faculty with more courses (four or five a semester compared to two or fewer at Michigan, Penn, and Harvard, which left faculty more time for innovation and research), more advisees, and more committees. As administrative staff ballooned everywhere, the number of tenure-track faculty declined. "Part-time" faculty, paid peanuts and denied benefits, with perhaps no more workspace than a chair and a desk shared with other part-timers, did the bulk of instruction once you left the elite institutions. (Graduate teaching assistants might be considered the equivalent labor force at elite universities.)

When I went to UMB to create what became the New England Resource Center for Higher Education (NERCHE), I wanted to put a finger on the scale for non-elite education. This inclination was natural to me. But the task wasn't easy, especially because New England is home to four of the eight Ivy League universities in the country and many other old, prestigious colleges, the combined force of which rest like a dark cloud over the many less selective colleges and universities in the region. The dominance of Harvard, Yale, et cetera, made

our efforts at NERCHE to build community and encourage experimentation at non-elite institutions even more challenging than they would have been in the middle west or the west.

I knew the only way to strengthen community was … to build community. But how? I took a chance and established a sort of think tank system, inviting people who all held the same position in their institutions: vice president or dean of students, vice president for academic affairs or academic dean, department head, and chief financial officer. Bringing people together on the basis of their common work, albeit in very different institutions, I thought, might help build community across the region. The think tanks also had to be challenging intellectually. We made sure to assign important readings to discuss with Lynton and me as discussion leaders. Holding to the principle of intensity that I had tested at the Residential College, I made sure that we met four or five times a year. At first, we did not charge a fee, but after three years of carrying the think tanks on NERCHE's meager budget, we introduced a small fee.

The first think tank, launched in 1988, assembled senior student affairs officers. I guessed that it would be easy to get conversations going across different colleges and universities among people in student affairs, and I was right. I asked a leader in the field, Cynthia Forrest, whom I had met at a national conference, to chair the student affairs think tank. She suggested members, and they were off and running.

At the end of our first year, we put on a conference, a kind of coming-out party for NERCHE, at the elegant John F. Kennedy Presidential Library near the UMB campus. I lined up my old friend Rosabeth Moss Kanter, from the Harvard Business School, to deliver the keynote speech; several other regional leaders in higher education attended as well. We publicized the conference throughout New England. The implicit message was that we were a classy operation at— surprise!—the poorly funded but ambitious Boston campus of the only public university in Massachusetts.

And sure enough, talk of waning support for public higher education popped up in all of the think tanks. I began working at UMass just as the state

began a series of funding cuts that continued through most of the eleven years I spent there. The cuts had dreadful consequences, sharpening the rivalry among already competitive faculty and staff scrambling to sustain themselves and their programs. UMB offered endless subjects for the think tanks to discuss; what was happening to public education in Massachusetts was one of them. We were an early victim of what has become a national trend of defunding education and the public sector in general, a neoliberal program of profound importance for our democracy.

I saw immediately that NERCHE was very vulnerable. We were the new kid on the block, and our block did not deal in the currency central to public colleges and universities—tuition and state dollars. I had some support from UMB's new chancellor, Sherry Penney, whom I knew from national circles, but it was clear to me that I would need to bring in money for NERCHE if we were to survive more than three years. So, I began spending the social capital I had brought with me from Michigan and from my involvement in national higher-education organizations. This meant getting grants—and fast. These grants, in turn, required staff and office support. The university supplied us with space: windowless offices on a corridor with other orphan programs.

With funding from the Mellon Foundation and the Pew Charitable Trusts, we carried out research on faculty work life in state colleges, regional public universities, and struggling private colleges. My writing and national reputation were strong in general education reform and liberal learning, and I easily secured a grant from the Exxon Education Foundation for a gritty study of the struggle to improve general education on non-elite campuses. A couple of years later, we shifted our focus to the civic work of faculty in their communities, a special interest of Ernest Lynton. All of these projects sent us to campuses across New England, which resulted in publications with the NERCHE affiliation prominently featured. When I retired in 1999, NERCHE was fairly well-known in New England and national higher education circles..

Graduate Program in Higher Education, UMB Style

Historically, UMB had not been permitted by the Commonwealth of Massachusetts to build doctoral programs. But in the late 1980s, Chancellor Sherry Penney saw an opening and decided to go for graduate programs in a few selected subjects, one of which was higher education. And so, not long into my first year at UMB, the provost approached me to develop a doctoral program in higher education. I told him that I could work on creating only one new program at a time and said I'd come back to him the following year—which I did. I assembled a committee, to which I invited a small group of thoughtful professors from different departments. I also made sure to include experienced administrators, since I needed their advice about the politics of getting a new—and not necessarily popular—program established at the university.

I challenged the committee to come up with a design that would not rely on late-afternoon and evening courses since I had taught a couple of evening classes at UMB, where students were exhausted from full-time jobs and family responsibilities. And, so was I. We needed to find another way. After searching for other designs around the country, we came up with a plan in which students admitted at the same time took two courses on Friday during the school year and another set of courses four to five days a week for three weeks in the summer: this was called the "cohort" model.

Officially founded in 1993, the program design remains pretty much the same today. Graduates are working in colleges and universities all over New England. The cohort design is a smashing success. It builds deep camaraderie among the students not very different from that of full-time, residential students—but with a greater sense of community. Elements of the program, especially the cohort model, have been copied elsewhere. Graduates are working in colleges and universities all over New England and beyond. They carry with them a sense of obligation to underserved students out of a commitment to justice. That the program continues to bubble along with each new cohort –while NERCHE survived 20 years—is a bit of a miracle.

The End of the Road

During my time at UMB, I evolved as a thinker, and I became ever more aware of the challenges facing public institutions of higher education. Whereas I began in my career at UMB by blandly using the language of "civic engagement" to talk about inequality in higher education, I wound up expressing my ideas more forcefully—in meetings, popular and scholarly writing. I wrote an article for the progressive humanities journal *Social Text* about the stratification of higher education, even as I watched UMB endure enormous cuts in funding from a state that was in pretty good shape. What happened to state colleges in Massachusetts and to community colleges was even more disturbing and all of this just down the road from some of the wealthiest and most famous colleges and universities in the world. I saw how with each cut, the culture of the university became tougher and more cutthroat, as departments and programs competed for crumbs. I found myself thrown back to my youth, when I felt the same kind of economic insecurity.

I was also getting older, and I was suffering from diseases caused by tick bites. Along with these, I had been diagnosed years earlier with fibromyalgia. All were conditions without a neat set of symptoms, which meant that the medical system, at a loss to understand what was going on, often blamed the people who were sick. I had never accepted this view. I had done research on how to help myself and sought out non-medical practitioners—acupuncturists, chiropractors, massage therapists, naturopaths, nutritionists, polarity therapists, and meditation groups. I was still sick when Bill began to be afflicted by a series of serious illnesses, including a life-threatening case of metastatic melanoma.

Between all this and the increasingly fraught culture at my university, I felt I could no longer function. I needed to protect Bill's and my health, as well as my peace of mind. So, after preparing my staff to handle NERCHE's work with several grants in place, I took an early retirement.

Looking back now, I don't regret that decision. I am proud of what I accomplished at UMB, especially in the integration of my work and political and social values. But I had run my course as a teacher, scholar, and practitioner. As I look around my study, I see a shelf of books and articles I have written over

several decades. They stand next to books and articles by friends, colleagues, and former students who have been important to me, people I have quoted and who have quoted me. More important to me are the students, faculty members, and administrators across the country and other countries whom I have touched.

I wish I hadn't had to struggle so much to find my own path. From the beginning, as a married woman and mother, my career in academia was shaky. Most of my academic women friends and colleagues from the 1960s and 1970s divorced early on, unable or unwilling to do it all. Bill and I stuck together—perhaps because our marriage was strong, maybe because we were both willing to live with compromise.

I can see now that if I hadn't had my children so young, I might have followed my interest in language into the fields of sociolinguistics and psycholinguistics, which were just beginning to emerge. Instead, it was easier just to stick with sociology and get my degree, which I did in a reasonable amount of time while setting up a household and taking care of two young children. Undoubtedly, I saved myself by refusing to labor on dinner parties.

And yet, like most women married to men in the same discipline, I felt cut off from my own field. All I had to do was look at the annual faculty photos of the Michigan sociology department, with its rows of white men. Once I put my foot down about not playing the good faculty wife, I realized that it wasn't a good idea for me to be dependent on Bill professionally. So, I stuck my chin out and decided I would find my own way.

I'm grateful for the breaks that came my way. From the moment I was ready to take on a job, I was the beneficiary of the old friends network; one thing always led to another. By the mid 1970s, I had defined myself as a reformer of undergraduate education. My work was guided by the belief in the intelligence of all people and my understanding that a strong community could nurture that intelligence. Community could instigate learning as a social endeavor and have an enormous impact--as it had in my own life. And although, as with most things in my life, I didn't set out with much of a plan, I see now that my work as

a teacher, scholar, administrator, program designer, and policy consultant was so that students would feel welcomed, respected, and free.

The little girl who thought college was a place to make mud pies wasn't wrong. I ended up having a career in higher education that I never planned. I was often frustrated and dispirited. But I never gave up. After all, every change could bring an adventure and with the adventure, joy and play.

9

Imbibing the Vineyard

BILL AND I FIRST SAW THE ISLAND OF MARTHA'S VINEYARD IN
the summer of 1962. He had been invited to a monthlong seminar on conflict
resolution at a conference center in Craigville, on Cape Cod. Spouses and fam-
ilies were included, so two-year-old Jenny, my round, very pregnant belly, and I
all tagged along.

One day during the seminar, Professor Roger Fisher, a faculty member
at Harvard Law School, and his wife, Caroline, invited the Craigville bunch to
their Vineyard place for the day. I was immediately taken with the calm beauty
of the place and wondered if we could afford to vacation there. Three years later,
friends came to visit us on the Cape. As we sat eating steak on our deck, they
asked, "Why are you having steaks when you could have lobster and fish?"

I admitted to them that we didn't really like where we were staying and
couldn't manage to find a fish store near us.

"Why don't you come to the Vineyard?" they asked. "It's much nicer
and cheaper."

So the next summer—1966—we packed up the kids, their gear, our work,
and some old clothes and headed to the Vineyard. There, we found just what
suited us: a summer cottage in Chilmark for $1,400 for the whole season. As we
always did, we carved out some space for work. I was writing a long report on the

student organizations study, and Bill was working on revisions to SIMSOC, a face-to-face simulation he created about how societies work, for use in teaching social science courses.

The cottage was big enough for the kids to have friends over—of course, a wonderful thing on rainy days, with a fire going in the stone fireplace. I asked around at Squibnocket Beach, where young families hung out, to find babysitters; a nice teen from Gay Head (now Aquinnah) joined our little world. I found out where to buy paints and paper for art projects, and the clerk at the stationery store in Oak Bluffs suggested that I also get thick crayons and rice paper to do gravestone rubbings, which we did several times in the oldest part of the nearby West Tisbury cemetery. (When I got back to Ann Arbor in the fall, I framed one of the rubbings of a child's gravestone from the early seventeenth century and kept it for many years.) We went to the fishing village of Menemsha for fried clams and lobsters. The island, and especially Chilmark, became our playground.

In short order, it also became our community. And what a community it was! Early in our lives, Bill and I realized we loved islands, going back to our romantic weekend on Kelleys Island, near Cleveland, in 1955. But none of the many islands we visited, while beautiful and relaxing, approached the Vineyard's diversity and sophistication. I felt that we had washed up on Utopia, compressed into a hundred square miles. We met longtime summer residents from New York, Connecticut, and Boston and hardworking locals from old Chilmark families, the fishermen and the farmers, the post office and town hall workers, the shop-keepers, and short-order cooks.

I had felt I was tuned to class from my childhood and adolescence in Philadelphia. In Chilmark, however, my class sensors got scrambled. I noticed that people intermingled regardless of whether they were wealthy summer people or local year-rounders. For reasons I didn't understand, the longtime summer residents wanted to be accepted by the locals, even if those locals were poor. The Vineyard in 1966 was an unpretentious place. You could identify the wealthy people by the musty smell that wafted from their old clothes, which they left in their closets over the winter; the locals dressed a little better.

In time, I learned about the difference between people from "old money" families, who did not display their privilege, and "new money" people, who did. While large houses existed on the island, they were nothing like the enormous places that people started putting up in the 1990s. Most summer houses in the '60s were modest places filled with books and games, musical instruments, and homemade furniture. They often had a wood stove and firewood stacked neatly on the porch. The children of the "summer people" ran free and mingled with the local kids, occasionally marrying them. Around this time, several summer people opened a folk café, the Mooncusser, in Oak Bluffs, featuring performances by musicians from the island (Carly Simon and James Taylor performed there) and other places.

Paul Sweezy and Leo Huberman, the editors of the socialist *Monthly Review*, began living on the Vineyard in the summer when land was cheap. E. Y. "Yip" Harburg, who wrote the song lyrics for the film *The Wizard of Oz*, also lived nearby. A mile or so down the road was the Barn House summer retreat community frequented by Roger Baldwin, one of the founders of the American Civil Liberties Union (ACLU), and some of his friends; Felix Frankfurter, a justice of the Supreme Court and the poet Sylvia Plath also spent time there. Just across the road from our cottage in 1966 lived Thomas Hart Benton and other artists who had likewise moved to the neighborhood when property was cheap.

Within the small confines of Chilmark, Bill and I felt we were in a cosmopolitan corner of the earth, a place with many accomplished people who kept a low profile. We were surrounded by people who, like us, had work to do but also loved the beauty of the place, went to the beach, had dinner parties, drank, and went boating, clamming, birding, and hiking.

We immediately noticed that the year-round people were friendlier than off-islanders. They loved shooting the breeze. As I wrote later in an essay about aging on the island, "We automatically make eye contact, shooting a little wave from the steering wheel." In later years, carpenters, landscapers, and the woman who delivered FedEx packages all liked to stop at my place for a few minutes for

a chat about the weather, our families, and the latest island controversy. I have had funny and profound conversations with them about getting older.

Knowing the people of the Vineyard was one thing, but the island itself was a whole world to explore. As we walked around and played outdoors, I started learning about the island's geology and its different habitats. The ocean, the ponds, the sounds, the woods, the grasses, the marshes—they were all mysteries waiting to be revealed to me.

On one of our first days on the island that first summer of 1966, I was at the beach with Jenny and Josh. We were walking along the beach when I noticed a woman walking around collecting seaweed from the shoreline. I said hello and introduced myself and the kids, who were playing in a small pool. She greeted me back and said her name was Rose. She told me she collected seaweed to make art; she explained that there were many different kinds of seaweed in different colors and shapes. As a child, I remembered seeing lettuce-green seaweed, brownish seaweed with bubbles, and seaweed that looked like dry black spaghetti when it dried, but no one ever told me that they were all different species of seaweed, with different names and properties. I realize now that I needed someone to interpret nature for me in order to appreciate its varied expressions. And Rose was my first Vineyard interpreter.

Rose saw where the kids were playing and said, "That's a tidal pool."

"A tidal pool?" I asked. I thought I knew the ocean; I had been going to the beaches in Atlantic City since I was a girl. I knew about sand in the crotch, sunburns, and skin peeling off in strips. I knew about tides and waves and salt-water taffy on the boardwalk, but I didn't really *know* the ocean. Here in the tidal pool, we saw shells running around on little feet. It was a funny sight. They were hermit crabs—tiny crabs that inhabited shells abandoned by their original inhabitants. It was a joy to learn about them from one of the books I bought for my kids and myself.

For the first time in my life, I found people who could teach me about nature, with which I had felt a close connection my whole life. I went on bird walks with Edward Chalif, who contributed several volumes to the Peterson

bird guides. I got interested in the island's geology and culture, including the federally recognized Wampanoag tribe, the Indigenous people of the island. The Wampanoags' descendants live primarily in the town of Aquinnah (formerly called Gay Head). I dug into the history of Chilmark and learned that it was incorporated in 1694; the white settlers traditionally survived on farming, fishing, and hunting. Starting not long before we came, tourism was added to the list, as locals realized they could make money by renting out their houses or building rental homes. This was the case with our first cottage.

The following summer of 1967, when classes were over at the university and school finished for the children, we rented another house on the Vineyard. As soon as we crossed the Bourne Bridge toward Woods Hole, where the ferry departed for the island, we breathed in the salt air and sang, "Oh, What a Beautiful Mornin'," even though it wasn't morning. The following summers, we rented different houses within a mile of where we had first landed in Chilmark. To afford these houses, we rented out our own house in Ann Arbor and, when we later bought a cottage on a lake near Ann Arbor, we rented that too.

Landowners

Finally, in 1975, we rustled up enough money to buy land right across the road from where we had originally stayed in 1966. Our land had once been a sheep pasture. It was available because the sellers, who lived on a hill above the pasture, needed the money to replace their just-completed house, because somebody had set fire to it. They had broken the unspoken rule that locals be given jobs on new building projects—and on the Vineyard, burning down houses was a fit punishment for breaking unspoken rules. There was a dark side to living in a small rural town.

Another dark reality struck later. Little did I know that our land was infested with ticks, worsened by the narrowing of their habitat, to which we ourselves contributed. I have pictures of me walking our land when the builders were framing our house. I am smiling broadly, wearing short shorts, standing barefoot in the former sheep pasture, This was where I contracted the first of

two cases of Lyme disease, followed a decade and a half by ehrlichiosis, another more serious disease caused by a tick bite. I thus unwittingly joined the majority of year-round residents of Chilmark infected with tick-borne diseases. Chilmark, with its history of sheep farms, was "Tick Central."

There was also something else that we didn't understand next door, which we didn't recognize at first: a commune founded in Boston by the musician Mel Lyman, who recruited members from Boston and Cambridge. Several years before we moved in, the commune migrated to Chilmark and occupied houses that belonged to one of the members. Members of the commune had been using part of the land next to theirs as a dump, and when we finally completed our house, a woman came to see me as I was working in the garden. "We won't be dumping on your land," she said, "and we like what you have built." While I hadn't thought about the commune one way or another, these assurances should have also been a warning that they were watching us.

In the end, they gave us a hard time only twice: one warm morning when the windows were wide open, Josh was playing loud rock music, and a woman from the commune came to the door to tell us that we were "disturbing our fishermen" who were trying to sleep. About six years later, three Israeli boys who were visiting with their parents wandered down to the commune's territory. The next day, someone hurled a mud ball studded with pebbles at the picture window in the living room, calibrated to dirty the window but not break it. I assumed that the missive came from the commune; we got the message.

Even ordinary communication could be complicated. One day in early 1984, our neighbor Fin turned up at my door. He said a local stonemason, Billy, was interested in a messy pile of foundation stones from an old sheep shed that had stood on our land. I didn't understand whether Billy wanted to buy the stones or what, so I arranged a morning meeting in the dining room over coffee with Billy, Fin as go-between. Billy was from an island family that dated back to the 1600s. He told me that he wanted the old stones for his business but couldn't pay for them in money. He wanted to do a trade and would build me whatever I wanted in exchange.

I asked Fin, "What is a fair trade?"

His answer, "Whatever satisfies both parties."

So that is how I ended up, a couple of months later, with two granite "balance" benches, eight cut stone steps up a hill, and a table and low benches made from the remains of the sheep shed. For arranging the match with Billy, Fin wanted a piece of granite with three hand-cut notches for a step into his kitchen. This is how I learned how bartering worked on the island—introductions, unspoken rules, trades of goods and services instead of money.

We didn't have any money to build anything on our land at first, so we waited. Before we bought the property, we had met with a young architect, a family friend, to see what was possible within the stringent restrictions that the sellers had placed on the land. Fresh out of architecture school, Sergio said, "Just tell me your biggest fantasies." I walked around the land, pointing left and right, telling him I wanted a house that goes this way and that. From a trip to Italy in 1969, I was taken with hill towns and wanted a house that climbed up the hill. I wanted windows here and a pathway to the garden there. With a height restriction, we had to get creative.

We started construction in 1979. The bills piled up, but we had a steady supplement to our regular income in the royalties from SIMSOC, which had become quite popular. When the house was completed, it was a joy to our family and friends. This was the kind of hosting I enjoyed, and we had many parties—deck parties and cocktail parties—with neighbors and friends from other places, including Israel and Japan. We collected our own mussels and cooked them with butter, wine, and herbs, or we would go to Menemsha, the fishing village nearby, to get lobster, speared swordfish, and other fish, all from the waters surrounding us, and cook them at home.

Most important of all, the family assembled at our house for Jenny's wedding at an inn less than a mile away. By the time of Josh's wedding several years later, we could hold it on the lawn in front of our house.

Year-Round Summer People

It was December of 1982, and I was dragging my suitcase through Detroit Metropolitan Airport, about to set off, alone, for Martha's Vineyard to finally get work done on *Liberating Education*. Just before my plane left, I ran into the sitting president of the University of Michigan. I told him of my plans to go to the island and write a book. He intoned, "Write a lot of words."

Odd advice, I thought. As I pondered what the coming months would bring, I thought about his words. *Be productive*, he meant, *work hard*. I wanted to complete the book, but I didn't want to be driven by pure production concerns, the way he seemed to suggest. I needed to clear my mind, to gather years of research together, to reach conclusions that felt new and significant. I decided I would call this a retreat—a chance for me to get quiet, enjoy my time together with myself, and maybe find out who I was at age forty-six.

I arrived at the new house in the early evening after the flight, a bus ride to Woods Hole, and the ferry. I was lucky to find a taxi idling by the old ferry station at that time of year. The driver took me to the house and helped me carry my things over the uneven ground that still awaited landscaping. I had only seen the house once at that point, in an earlier stage of building.

I was floored when I saw the finished house. I ran from room to room, turning on the lights and marveling at the elegance of Sergio's design. Instead of building a house atop the hill, like a motel hogging the best view, our house was built *into* the hill. We had views of the pond and woods, but because the house was built on three levels, no one window yielded the same view.

The island in the off-season is nothing like it is in the summertime. While the Vineyard first wooed me in the summer, with its sunsets, lobster dinners, and beaches, I came to love the island my first winter there. Worried that I would work all the time, given my old workhorse tendencies, I set up a very strict schedule for myself. It went a little like this:

8:00 a.m.–10:00 a.m.: Meditation and breakfast

10:00 a.m.–1:00 p.m.: Writing

1:00 p.m.–3:00 p.m.: Outdoors

I had packed an old family camera that we had used for years of travel and took it with me in the afternoon wherever I went. I photographed everything—sea, beach, woods, gingerbread houses. I have kept a photograph of a favorite gingerbread house I took in the Methodist Campgrounds in Oak Bluffs, several of the ocean in calm and tempestuous moods, geese and swans flying in formation, and close-ups of tall grasses.

In the afternoons and evenings, my routine continued:

3:00 p.m.–6:00 p.m.: Correspondence, telephone calls

6:00 p.m.–11:00 p.m.: Dinner, spiritual readings, novel

I was drawn to spiritual readings from India and China—the Bhagavad Gita and the I Ching—and the Buddhist teachings from Thich Nhat Hanh about the spiritual meaning of everyday life, emotions, and nature.

During this time, I was free to do exactly what I wanted, the way I wanted, with no interruptions. No one expected anything from me, and I could disconnect the phone when I was working and really focus on the task at hand. With my neighbor Fin's help, I shifted my study to the loft over the bedroom and worked at a long table. Beside it, I placed an easy chair. The setup allowed me to keep my workspace separate from my living space and, every morning, I climbed the ladder from the bedroom/study to the loft/workplace. My attention was drawn to the window overlooking the roof. Through it, I could see Menemsha Pond, the houses on the other side of the pond, the crows that arrived in the morning, and the pair of red-tailed hawks that patrolled the area.

I wrote painfully, wrestling with piles of interviews and data from the fourteen campuses in the project. By starting from affection and letting nature teach me about patience, I wrote a sweet book about our efforts as educators to find common ground. In it, I talked about the values we shared toward serving our students—how we wanted to let them experience expansive, free thinking so they might make a difference in the larger world.

In the process of writing the book, I was coming to understand myself better. I was surprised by how much I, generally an extroverted person, was enjoying being alone. It was the first time I had ever truly lived alone; I had gone straight from living with my family as a girl to having a roommate in college to moving in with my husband. Being alone meant I could focus on one thing at a time and pay attention to what my body was feeling. I felt creative, energized, and peaceful in our wonderful home. But on nights when the wind blew, I could have done with a little company. There was a corner of the loft where the wind cut through so hard, it whistled. It was a bleak and lonely sound, but I talked myself into thinking of it as a sort of music. Early in my stay, I called my old friend and colleague Marilyn, who had invited me to the May Day demonstration in 1971, to tell her how much I was loving solitude. And Marilyn, who had taken a different path than mine, and who, after a marriage with two kids, had come out as a lesbian and moved to New York, asked me, "What were you waiting for?"

I led a healthier existence in Chilmark, in more ways than one. Since my days at Antioch, I had smoked a pack of cigarettes a day. During my retreat on the Vineyard, I left to attend a conference at Goddard College on the invitation of my old friend from Cambridge and CORE, Mary Belenky. When I broke out a pack of Marlboros at the conference, Mary rebuked me by saying, "Zelda, are you still smoking?" It turned out that she had recently stopped smoking, along with a group of friends who had agreed to donate to the worst organizations they could think of, should they smoke again.

I told Mary I had tried to stop smoking several times over the years and had not been able to stick to it. But while in Vermont, I thought about Mary's pact, and by the time I left, I told her, "Okay, Mary, if I ever smoke again, I will give five thousand dollars to the Ku Klux Klan," as I threw away the remaining cigarettes in the Marlboro package. "But," I said, "I can't be responsible if *she* smokes again."

Twenty-six years later, I was interviewed for an episode of the NPR program *Radiolab* about the Ulysses contract, a commitment in the present to carry out a decision in the future. Again, I repeated, 'I couldn't be responsible if she smokes again."

The interviewer asked me, "Who is 'she'?"

"The bad me," I answered.

And that is how I became famous in the world of *Radiolab* as the old lady (they made me five years older than I really was) who stopped smoking by swearing to give a lot of money to the KKK but couldn't promise that "the bad me" would go along with the scheme.

That first winter, I knew only a few people in Chilmark or any of the other towns, and I didn't particularly want to meet anyone. Occasionally, I would take myself to see a movie at the only movie theater open in the middle of winter. After a few visits, I started recognizing the regulars. The theater was small, and one night, I and another person were the only two people sitting in the theater. We were told to go home; I learned that four people was the minimum for showing a film. When there were just a few of us, we would spread ourselves out in the theater so we could feel like a real audience.

I often needed to copy something, so I would go to the little town hall a half mile away and pay by the page to use the copier. I would see people there, and after a while, we said hello. They didn't go out of their way to be friendly. After all, people were turning up in Chilmark all the time to write, paint, or just get away from their off-island lives, and then disappearing again.

Soon, though, Bill and I would reach an acceptable step in the Chilmark class ladder that started with summer renter, then summer resident non-voter, then summer resident voter, and then year-round renter, year-round renter voter, year-round resident non-voter, and ended with year-round resident voter. When we registered to vote in Chilmark in the early 1980s, we could grow some roots.

Staying Put

When I retired from UMB in 1999, it was a great relief to stay put on the island. Bill continued to commute to Boston College. Now a fulltime island resident, I gave myself six months to figure out what I would do with myself on the Vineyard. When people asked me to join them on a committee, I declined, saying I needed time to think. "Wasn't I nervous that I wouldn't know what to do every day?"

people would ask. In fact, I was quite happy to not know and enjoyed the liminality of this new stage of life. When I told colleagues and friends that I was not going to use email for six months, most were mystified or even insulted; even in those days, the Internet had wormed its way into people's lives, already becoming seemingly indispensable.

This retreat was unlike the one I had created for myself in 1982, when I stayed in our just-completed house to work on *Liberating Education*. Now, seventeen years later, I didn't have anything to accomplish—no goals, no focus.

Then I began feeling depressed. It got so painful that finally I saw a therapist. When I finished the first session, I asked him what he thought was going on.

"Simple," he said, "you're having an identity crisis. You gave up an identity that was rewarding for you and don't know what will replace it. Enjoy the openness of liminality and you'll reach the other side of it when you're ready. The most important thing is to not jump too soon into something just because it will replace 'professor' with something else."

I took his advice.

Becoming a Local Yokel and Returning to the Piano after Fifty Years

I decided that whatever I did would take place on the Vineyard, that it would focus on some aspect of inequality, that it would bring me in touch with Jewish subjects, and that it would include music. Among the first people I met on the island were Warren Doty, a historian, fish broker, and selectman who became a close friend, and John Abrams, the founder of a design-build company with roots in the worker cooperatives I had explored in the '80s. John is a visionary—a term I do not use lightly—whose shelves held some of the same books that mine did. In an important decision, I told Warren and John that I wanted to focus my energy on affordable housing on the island.

I went at it slowly and deliberately. In early May 2000, I joined a small band of women who organized a forum on affordable housing. I will never forget that meeting—people in sturdy boots and work clothes crowded into the Grange Hall in West Tisbury. Several talked about growing up on the island

but said they feared they would be forced to leave because they could not afford the cost of housing. Some described their summers living in a tent in the woods or in their cars with their families. This was the first time I heard the expression "the Vineyard Shuffle": once the summer began and landlords could charge a lot more for their houses than in the off-season, year-rounders had to move out and "shuffle" off to another living arrangement. "What can I do?" a carpenter in his thirties asked me with tears in his eyes. At the time, I didn't know.

Several of us decided to answer his question, though we knew that it would take a while to solve the problem. First, we decided that we had to raise awareness about the sorry state of housing on the island. At the same time, we would have to build an infrastructure for funding affordable housing. A group of us formed SHAC (Secure Housing Action Committee) to get the word out in dramatic fashion. We marched in the July Fourth parade in Edgartown, handing out eviction slips to the people crowding the sidewalks. I set Bill up with a wheelbarrow draped with a mess of clothes and gardening tools while I carried a sign that said, "We Need a Secure Bed for Ourselves and Our Garden." Well, actually we had several secure beds, but that didn't stop us from agitating.

As awareness grew, I turned to the problem of infrastructure that could actually produce more affordable housing. I founded the first housing committee in Chilmark, and we slogged our way through changing zoning bylaws so people could build affordable housing on small lots. We identified a state funding mechanism for affordable housing, the Community Preservation Act, and brought in a decent amount of money. We planned a cluster, on town-owned land, of six beautiful rental units and six lots for houses that would go to the winners of a lottery to build their own houses. Many meetings and several boards and committees later, helping younger members of the labor force with housing was a difficult but not totally impossible part of the Vineyard landscape.

On the Vineyard, people worry less about aging and its problems than they seem to do in the city, even though the proportion of people who are sixty-five or older is higher. I wrote an essay on aging for *Jewish Currents* not long before leaving the Vineyard, titled, "Gevalt, How Did This Happen?" I wrote with

admiration about friends older than me who still wore bikinis and rode the waves, women who farmed, who served on boards and committees with younger people. They have figured out how to conduct their lives. They are musicians, artists, and writers who are still creating. They tend to live to a ripe old age.

I, too, found time for art, returning to the piano in 2003, almost fifty years after I stopped playing. I found a brilliant teacher on the island, a graduate of the New England Conservatory of Music. I didn't have a piano yet, and when I discovered that I couldn't read music anymore, I was ready to give up. But my teacher reassured me that my fingers and brain would remember. After a few weeks of lessons and practice, I was able to play beginner pieces, and gradually I worked my way back to my beloved Bach and Debussy. At that point, I bought myself a Yamaha electronic piano, which I play passably if I practice. It gives me great pleasure to make music. I spend some time noodling around making sounds, and then I pull out the scores.

Alongside my commitment to affordable housing and my reunion with music, my years on the Vineyard marked a new phase in my relationship to Judaism. In the 1990s, Bill and I joined a Reform synagogue on the island, our first time as members of a synagogue—unless you count my clandestine forays at age twelve. And although we joined to meet other Jewish people, not for a religious connection, once I began attending Shabbat services, I found myself drawn to Judaism through the Torah. I took to the Saturday morning discussions of the Torah portion of the week based on the stories of Abraham and Isaac, of Moses, and of Joseph and his brothers. I learned the Sabbath and High Holiday prayers not through any formal religious education but by osmosis and repetition. I felt a sense of comfort there.

Ten years later, my role in the community had gone beyond prayer. I created a social action committee and started a speaker series about the Middle East, featuring both Israeli and Palestinian perspectives. Naively, I thought our congregation supported honest discussion of the Israeli government's policies. But after fifteen or so programs, after one member took me aside to tell me that these gatherings sowed discord and made Israel look bad, I suggested that the committee

shift its focus to social action on the island instead. My frustration with Israel's policies only deepened, but I did not want to split the congregation. I focused on my non-political interests, joining the choir for the first time, serving on the board of trustees, teaching a course on Yiddish writers, distributing money to organizations that served people in need, and participating in holiday celebrations. Since that time, more members of the congregation have become critical of the Israeli government. Now, in 2023, after extreme measures by Netanyahu and his coalition partners to solidify their position, more members of the congregation have joined me.

Bill, too, became part of the Vineyard congregation. When he was already living with dementia, he decided he wanted his own bar mitzvah. He had seen other people his age do this. He was aware that he was having trouble with his brain—a neurologist at Massachusetts General Hospital had confirmed this—so, as with so much else in our marriage, he counted on me to help him. I selected a date, invited friends and family from off-island, and lined up a caterer. When he could not focus well on his speech, I rewrote his draft. Then I suggested that he write another speech about why he was having a bar mitzvah at eighty-three, and that part came out well. I arranged for tutors to teach him to chant the Hebrew prayers, two lovely young women who worked hard with him, though by the time the day came around, he could not remember much. Regardless, the day turned into a kind of wedding, with a big party, lots of visitors, and family at our house.

Since I first set foot in Chilmark in 1966, the island has been discovered, no doubt about it. With two presidential visits and a few celebrities came more celebrities, millionaires, and billionaires. Demand has driven the price of land sky-high, and ordinary people cannot afford it. The old-money vibe of Chilmark has given way to a playground for captains of industry, bankers, hedge fund managers, and lawyers. On the other hand, the island continues to be a magnet for musicians, novelists, and artists, as well as activists working on the food system, sustainable agriculture and fishing, and protection of animals and habitats. Somehow, they find places to live, either with each other or with families who own property.

People have asked me why I love the Vineyard so much. Some feel trapped on an island. But not me. On an island, not everything is possible, and I like that constraint. You are bound to the land, and it is bound to you—holding you up, keeping you there.

Once many years ago, I got mad at Bill. He had invited his family to stay, and I found myself making beds and doing all the cooking. Fuming, I got in the car and drove as fast as I could until I reached one end of the island, in Edgartown. Then I turned around and drove as fast as I could to the other end, at the Gay Head cliffs. I was at one limit, then turned around to run into another. Standing there at the edge of the island, my anger smoldering, I realized that as hard as you try, you can't get very far. On an island, you have to face yourself and what is there. And then I asked myself why I would want to run away from this place anyway. Once you're there, you're in heaven. You turn around, drive home, and find that you can love the people you're stuck with.

10

Here I Am

Either you will

go through this door

or you will not go through . . .

The door itself makes no promises.

It is only a door.

—Adrienne Rich,
"Prospective Immigrants Please Note"

I STILL CAN'T SEE THE BIRDS FROM MY APARTMENT WINDOW—
no cardinals or nuthatches or chickadees, like those I could see from my house on
the Vineyard. But writing this book has allowed me to see many other things, some
of which I knew, but many of which it's taken me until now to fully understand.

The psychologist Erik Erikson wrote about the eight stages of life, starting
with the establishment of trust (versus mistrust) in Stage 1, infancy, to Stage 8,
integrity (versus despair) in old age. Stage 8 comes after child-rearing and working,
when reflecting on life, including one's own, surges. Well into my eighties, I've
lived longer than my mother and all my grandparents. I have been at Stage 8 for
a long time, and writing this book has been a part of my reflections. I've reached

deeply into memories and scenes from when I was young, held them up to the light, and set them back in their emotional and spiritual places.

Also in their places are the objects I've gathered and held onto over the decades. Some of them I still use, like the desk I'm sitting at as I look out at the mismatched facades of the neighboring building, or the basket of scores that sits near my piano keyboard. Others, like photographs, help me remember. In one, I stand in my blue dress on prom night, next to my sweet, forgettable date. On my refrigerator, I keep a picture of our house in Chilmark; I still subscribe to the *Vineyard Gazette* and visit the island as often as I can. In one album, there's a photograph of Bill and me in the early '90s, dancing. In my phone, I save a photo from 2021, when I got him out of his hospice bed to move with me to the Latin music I found on the TV in our bedroom. That one breaks my heart, because he was dead a few weeks later.

Time moved slowly –and then at fever speed—to the inevitable end. By the time the pandemic hit in 2020, Bill was only half present. His desk, immaculate a few years ago, was now a snapshot of a messed-up brain: papers piling up with each mail delivery, waiting to get lost. It didn't help that he couldn't hear without hearing aids, which were perennially on the fritz. When I asked him to make breakfast, I prepared myself for an hour-long wait and a mess of dishes, smudges, and crumbs—that is, if he remembered what we agreed to eat. When he did remember, I was grateful, and he felt useful.

I am desperately sad about what had happened to my partner and playmate. When I received the results of endless scans of his brain, questionnaire and psychological tests, I checked neurology websites for research, in the hope that there would soon be a cure for dementia. That's when I started pulling out photo albums to find the old Bill: there he was, in a baseball cap, sailing our Sunfish in Menemsha Pond. There he was again at our granddaughter's bat mitzvah, dancing the hora around the room, grinning. And again, at a sociology convention, celebrating his presidency of the American Sociological Association, wearing a long blond wig with his suit and tie. And beard. His eyes were always bright, his look knowing. He was a guy who always knew where he was and why.

Now, his eyes were dim. He knew where he was but not why. He'd lost his sense of humor and ability to reason. When he tried to fix anything, he broke it. He didn't have a clue about how to navigate his computer or even the TV remote. I never gave up on him because to me he was still Bill. Even when family and friends tried to say he wasn't, I knew otherwise. After all, I had lived with him for 65 years. I pulled him up to dance. Pushed him to create a skit with me for a contest on tv. Lined up a guy with a guitar who led singalongs on Zoom. Subscribed to several meal kits so he could cook with me. Played Scrabble. Watched "Jane the Virgin" and "Call the Midwife", his surprising favorite new tv shows.

Every part of our life together now was a problem to be solved, and I was the one who had to solve it. In the past, I'd been able to count on Bill to handle our finances, but after several serious errors that could have ruined us, I took over. Meanwhile, Bill relied on me to confirm that a given day was Tuesday or Wednesday; help him to put in his hearing aids; make medical appointments, to figure out how to get us there in our new carless existence. I became a small-appliance fixer, a computer jock, an Internet researcher, an entertainment curator, and the operator of a nursing home.

Before the pandemic, our family suggested that we consider an assisted living community. After my son-in-law's parents died early in the pandemic in an assisted living residence, they backed off that idea and helped me navigate the pandemic and Bill's needs in our apartment. I could see that living independently would load more on me and that it could become a trap. I would get angry and frustrated with Bill. My family didn't like it when I did, though they knew I loved him and did everything I could to help. I had a few good friends who lost a beloved partner who understood why I was angry and tearful at the same time.

Bill died a couple of months after his 87th birthday and 11 days after my 85th. I found him in his hospice bed, and knew he was gone. He was lying in a relaxed pose, his right hand above his head and left hand on his stomach, pointer finger directed at his navel. A cancer, sarcoma, got him in less than the three to six months the oncologist had given him. He was never in pain and still had some of his capacities before he died, enjoying a wheelchair walk with Jenny and her

husband to the park wrapped in a blanket, sitting up in his bed to visit with a dear colleague, who arrived with a posterboard of photos to prompt his memory.

The night before he died, I went looking for something we could watch on the television, as we did every night. Up popped Eddie Murphy's *Coming 2 America*. I thought it might suit Bill—colorful, simple plot, pretty women. Instead of falling asleep as he usually did, Bill stayed awake throughout the whole movie. 15 minutes into it, he broke me up:

"Wow! It's over the top!", he said.

That was the last I heard him speak and it was the old Bill—focused and funny and playful.

I had never seen a dead body before and was shocked to see Bill's. But he was still Bill, and I didn't want to let him go. I called Jenny and then lay down next to him with my head on his chest and my hand on his bald head, hugging him, talking to him. Jenny called our new rabbi in Boston, who arrived right away, and we held a service in the bedroom where he lay, with the rest of the family patched in by phone. When the funeral people came to take him away, I refused to go into another room, as they suggested. I watched as they zipped him into a black plastic bag as they wheeled him out.

With the help of our Vineyard rabbi and her husband, also a rabbi, we buried him two days later in the Abel's Hill cemetery in our town of Chilmark, across from an anarchist, in front of a storyteller, and a few yards from John Belushi.

Josh, Jenny and I made sure that Bill got his due, with prominent obituaries in the *New York Times* and the *Boston Globe*, which made much of him as the "father" of fantasy sports and less fanfare about his contributions to scholarship about social movements, media and the creation of the simulation of society, SIMSOC. We hosted a memorial on Zoom attended by more than 200 people and collaborated with his students and colleagues to hold special sessions on his legacy as a scholar and political activist. His students are his greatest legacy as they go through their lives carrying Bill into their work. His writings are online; I have deposited them in the faculty archives at the Bentley Library, the University of Michigan.

I thought I knew Bill well when he died. But in the time since, after going through many boxes of stuff from his office, I've learned a lot more. I discovered a paper he wrote at Antioch, required for graduation. In it, he reviewed his life to date. The type was so faint it was almost as if it had been written in invisible ink, and I had to run it through the copy machine again and again until the text emerged. I was taken aback when he revealed that he had frequently cut class at Central High in Philadelphia, a competitive boys' exam school that he described as a "factory to college." He became a sportswriter, then sports editor and editor of his yearbook. When he got to Antioch, he wrote, he wanted to be a creative writer. But the one and only creative writing professor there told him he wouldn't do well as a fiction writer. So, Bill cut that professor's classes too. He didn't know what he wanted to do with his life, except not go into his father's coat and suit company. Maybe become a lawyer?

That was Bill in his freshman year. How had he become the serious student I met when he was in his senior year, with his hour-by-hour schedule and reading machine? In his paper, he describes taking a demanding course in his sophomore year with Heinz Eulau, a German Jewish refugee in the government department. That was when he fell in love with the social sciences–– the surveys, the math models, the analysis of human behavior. Although Bill and Eulau tangled on several fronts, Bill stuck with his professor because, he wrote, he figured he could be useful.

During that time, he also went on a self-improvement campaign in the arts: he would walk to his co-op jobs with his nose buried in a novel. He took himself to art museums and classical concerts. He built a small collection of records, mostly folk, some classical. It has struck me only recently that my own background in classical music, along with the self-discipline and work ethic I'd had since I was a kid, might have been attractive to Bill. Maybe, also, he valued his attachment to my radical poet father, who quoted Walt Whitman and Tom Paine, and to my mother, who loved having fun.

Another item I found when I dove into his papers was a poem he wrote in 1955, soon after we met:

Observation on a State of Affairs

The Reporter is a magazine
Which one reads bi-weekly;
But I say, meekly,
I read her more often.

Vitamin pills are little round things,
Which one swallows die-ly;
But I say, dryly,
I swallow her more often.

A wrist watch is a little clock,
At which one gazes hourly;
But I say, dourly,
I gaze at her more often.

Oneself is a thing one thinks of,
Not more than yaz-ually;
But I say casually,
I think of her more often.

But Zelda like the poor,
Is always with one historically,
So I ask, rhetorically,
Isn't that a bit too often?

What a clever boy he was to capture himself as we were falling in love, not knowing what was waiting for him? Such a bittersweet feeling I get when I read this poem. We worked and played hard, and that took its toll. My own ambitions and choices were often shaped around his, and never the other way around. Late in life, when we moved into our Brookline apartment, where I'd had two studies built—one in a second bedroom and one in a walk-in closet—I offered the larger one to Bill. My first room of my own, and I was prepared to give it to him, even though he could no longer work! Thankfully both Jenny and Josh said, "No, you should have it," and Bill was tucked into the carrel-closet that has now turned into a kind of

shrine to him, where I have displayed all his award plaques, pictures, books, and files. Though we weren't always happy, we were always friends, always lovers. We danced together, traveled together, stayed together.

What now? Not far from my apartment building, there's a little park where I go to stand under the old trees. I especially love the weeping willows, and the birds, squirrels, creeks, kids, and dogs. I enjoy feeling that life is going on. Although Brookline doesn't feel like home, I'm getting used to it and finding little joys. I go out with friends to a museum or farmer's market or invite them over for lunch. I can't see mourning doves or wild turkeys from the sixth floor, but I hear the clattering of the train below. In the summer, when the windows are open, I can hear the recorded announcements: *This train goes to North Station . . .* It's familiar territory to me, going all the way back to Philadelphia, where I rode the trolley cars from the time I was nine.

As I slip into my last years, I fall in love with nature more than ever. For me, "God" is the force underlying all living things—planets, suns, birds, dogs, creeks, kids, wind, rocks, you, me. Sometimes, when I see a bird or a tree, I say, "Hello, God," or, "Hello, you beautiful creation." I felt that spiritual connection even as a child, in Tookany Creek Park. Even in the city, an invisible cardinal's spring song opens my heart to something larger. So does the parade of dogs on the main drag. Gazing up at the stars from my balcony, I join the universe.

I am still not at peace—with myself or with the world. I'm not resting a whole lot. Even during the pandemic lockdown, I was as busy as ever with friends and family, exercise classes, writing postcards during the 2020 presidential elections. Now, I can't believe it but I find myself fighting once again for a woman's right to control her body!

There are signs that life is winding down around me. I read more obituaries than I used to. I attend more funerals and memorials and have written more eulogies and poems and a song or two about friends who have died. I cherish those who remain and find myself checking in with friends I haven't heard from in a while.

As I write these words, it's almost summer of 2023. Along with my art and shoes and books, I have filled my apartment with birds: birds in metal, birds in clay, birds in glass, birds in fabric. They don't make up for the birds beyond my windows, but they're reminders of what I love most—the natural world, freedom, beauty. I am still dancing and traveling. I still want to learn all I can about any number of things, including my own life.

Soon, I'll head to the Vineyard. I'll spend as much time as possible outside. With the pandemic winding down, I'm entering a new period of liminality in which I will dig deeply into myself to see what I will be next. I am sure I will find the answer. Or the answer will find me. I suspect that it's lurking in this book.

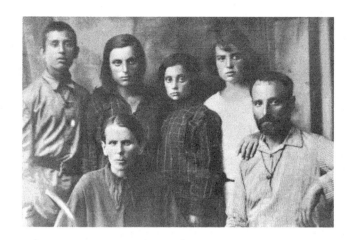

Tsybelov, Ukraine, Ladijhinski family, Reba on back right, 1925

Philadelphia, Zelda at age three, 1939

Marshall Street Philadelphia, 1940

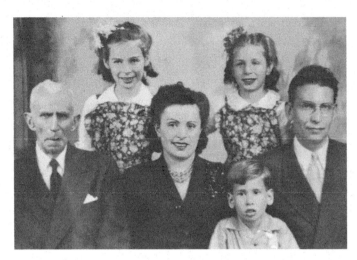

Philadelphia, front row great-Uncle Shapiro, mother,
brother Harry, father, back row, Zelda, sister Anita, 1943

Philadelphia, 6th Street, front row, cousin Sandy, brother Harry,
back row, Zelda, sister Anita, cousin Melvin, 1944

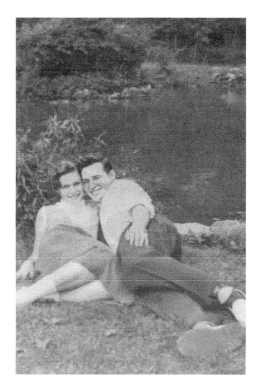

Philadelphia, with Billy Roseman, 1952

Philadelphia, Olney High School pals,
Zelda third from right on the floor in the back, 1953

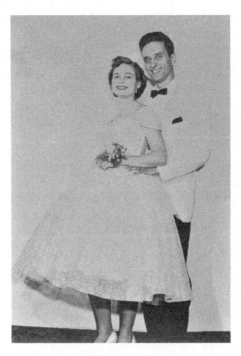

Philadelphia, Olney High School senior prom in The Dress, 1954

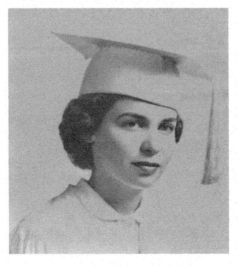

Olney High School graduation, 1954

Phoenixville, PA, Zelda on left, with other camp counselors, 1954

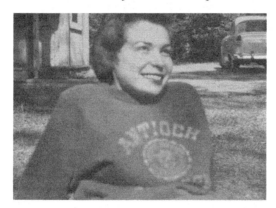

Antioch College, Zelda, 1954

Acapulco, Zelda and Bill, 1958

Washington D.C, Affinity group, Mayday
Front row, Marilyn Young on far left, Zelda on far right
Back cluster, l-r: Howard Zinn, Daniel Ellsberg, Noam Chomsky, 1971

Barcelona, 1972

Palo Alto, California,
Zelda and Bill dancing to Saturday Night Fever, 1972

University of Michigan Center for the Study of Higher Education,
graduate students and Zelda, 1975

Ann Arbor, 1979

Martha's Vineyard, construction of the guest house
from l-r, Zelda, Len Butler, John Early, 1981

Martha's Vineyard, Zelda at her desk, 1982

Martha's Vineyard, Zelda, 1984

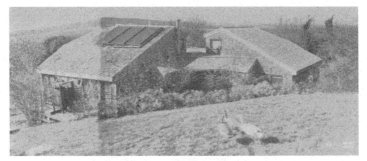

Martha's Vineyard, Main house, 1990

University of New Mexico, Zelda, 1999

Martha's Vineyard, Guest house, 2001

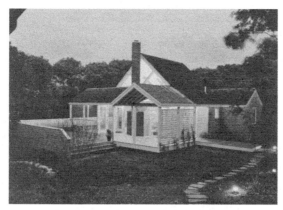

Martha's Vineyard, Guest house, 2001

Martha's Vineyard, Sailing, 2002

Boston Common, Pro-choice demonstration, 2005

Galapagos Trip, 2008

Martha's Vineyard, with Reba and Maddy, 2014

Boston Common, Women's March, 2019

Brookline, MA, 2019

Martha's Vineyard family portrait, two grandparents, one daughter, one son, two sons-in-law, five grandchildren, 2019

Martha's Vineyard, Grandkids
Front, Gilad
Back l-r, Maddy, Reba, Maya, Ari, 2019

Newton, MA, Owlets, 2022

Acknowledgments

I am grateful to my late husband for trusting me to write about him without ever reading a word of what I say. My descriptions of him over the sixty-seven years from the time we met until his death are my own experience of him, conversations and scenes colored differently by the different stages of our lives together.

Writing this book has given me the opportunity to learn about myself and the worlds in which I have lived. In telling about those worlds, I watched myself coming and going, stopping to look, and, in the fullness of adulthood, rushing through. The process of writing helped me recover many memories. With them came music and images; people and places rose up again to greet me.

What did these memories mean?

For a long time, I was convinced that my life was simply a pastiche of interesting experiences that didn't make overall sense. Not an unusual feeling, since women, especially from my generation, tended to put off having (or never had) a single trajectory in our lives, an understandable and rational result of the fact that we weren't in control; we had to wait to see what our husbands were going to do. If women were not married, they had to navigate discrimination and sexual exploitation; hardly the best conditions for developing agency.

As I wrote, I came to see that the many parts of my life do fit together. They're like the tributaries of a river, maybe—curving here and there, sometimes

spilling over, sometimes close to dry, but always belonging to the primary river, always flowing, together, in one direction.

I might not have written this book if I had only sat alone in my study. I was fortunate to know Jeri Dantzig, as well as Ellen and Steve Levine, friends with homes on the Vineyard where I could keep an eye on the antics of birds while tapping on my computer.

I am grateful to Mano Silveira, Molly Lindley Pisano, Kate Castelli, Ellen Dubreuil, and Edney Monteiro for their help with preparing the manuscript for publication. Friends and relatives played back to me their understanding of what I'd written, pushed me to say what I'd intended, and followed up with critiques, clarifications, and suggestions. I thank Josh Gamson, Olivia Hull, Susan Klein, Jillian Kravatz, Gilad Seckler, Kathryn Kish Sklar, and Susan Quinn for their clarifying questions. Thanks especially to Anna Solomon, for asking the really impossible questions.

—Zelda Gamson
Brookline, Massachusetts
June 2023